D0576565

Painting is a journey.
It is the way
I mark my path through life.

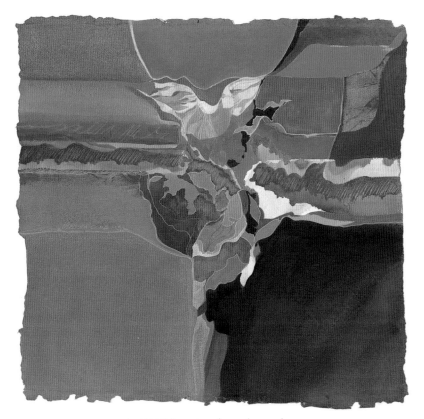

JOURNEYS 3, watercolor and gouache on
handmade paper, 32″ × 32″ (81.2 × 81.2 cm).

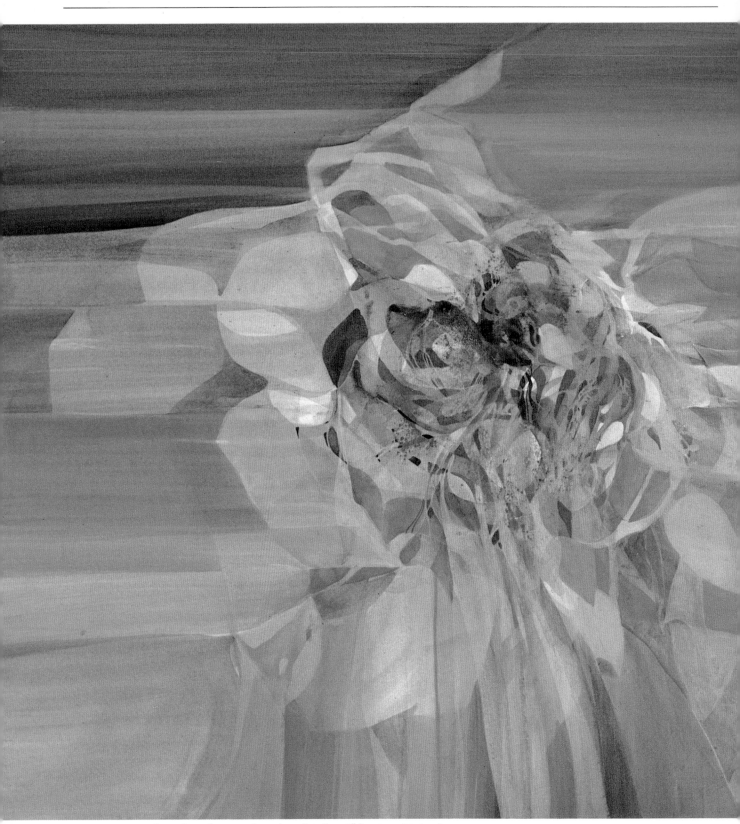

NESTING 3, watercolor and acrylic on 4-ply rag board, 32″ × 40″ (81.2 × 101.6 cm).

Virginia Cobb

DISCOVERING THE INNER EYE
Experiments in Water Media

WATSON-GUPTILL PUBLICATIONS/NEW YORK

This book is for Ruth who was the beginning,
Julie who is the future,
Wayne, Stuart, and Bruce.

The photographs on the following pages are provided courtesy of
Bob Bluntzer: pages 12–13 (top row), 16, 17 (top right), 18 (bottom),
20 (middle row, right), 24 (top left); Polly Hammet: pages 12–13
(middle row); Katherine Hautg: pages 18 (top right); 56 (bottom);
Norma Jones: page 20 (top row, left); Robert Hogue: pages 88, 89.

Sources for quotations appearing in the book are as follows:

Page 5: *The Way of Liberation* by Alan Watts, 1983, John Weatherhill, Toyko .

Page 11, 13, 129: *Ben Shahn,* edited by John D. Morse, Praeger Publishing Inc., New York, New York.

Page 73: *Einstein's Space and Van Gogh's Sky,* by Lawrence LeShan
and Henry Margenau, 1983, Macmillan, New York, New York.

Copyright © 1988 by Virginia Cobb

First published 1988 in New York by Watson-Guptill Publications,
a division of Billboard Publications, Inc.,
1515 Broadway, New York, N.Y. 10036

Library of Congress Cataloging-in-Publication Data
Cobb, Virginia, 1932–
 Discovering the inner eye.
 Includes index.
 1. Painting—Technique. 2. Visual perception.
I. Title.
ND1500.C63 1988 751.42 87-31817
ISBN 0-8230-4889-6

Distributed in the United Kingdom by Phaidon Press, Ltd., Littlegate
House, St. Ebbe's St., Oxford OX15Q, England.

All rights reserved. No part of this publication may be
reproduced or used in any form or by any means—graphic,
electronic, or mechanical, including photocopying, recording,
taping, or information storage and retrieval systems—without
written permission of the publisher.

Manufactured in Japan

2 3 4 5 6 7 8 9 10 / 93 92 91

"Kindly let me help you, or you will surely drown,
said the monkey,
putting the fish safely in a tree."

<div align="right">ALAN WATTS</div>

In painting we are each individual in our
expressive needs, our view of the world,
our sense of what is beautiful.
These traits of character determine our choices
of images and symbols,
the important element of painting
which cannot be taught.
The tools of painting, design, and technique
can be formulated, and they become our
vocabulary of painting.
It is through trial and through experimentation
that we find the creative form which best
suits our individual expressive needs.
In this search we are each
an experiment of one.

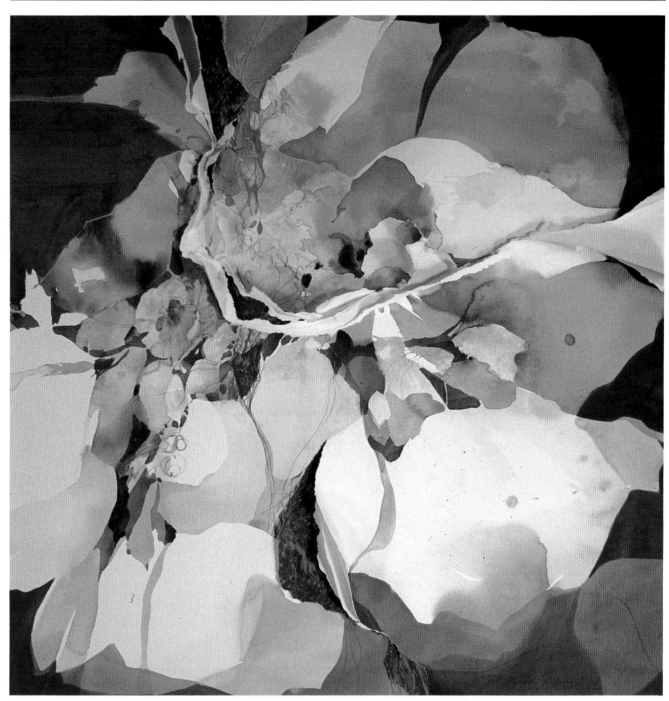

LIFE CYCLES 8, watercolor on layered board, 34″ × 34″ (86.3 × 86.3 cm).

Contents

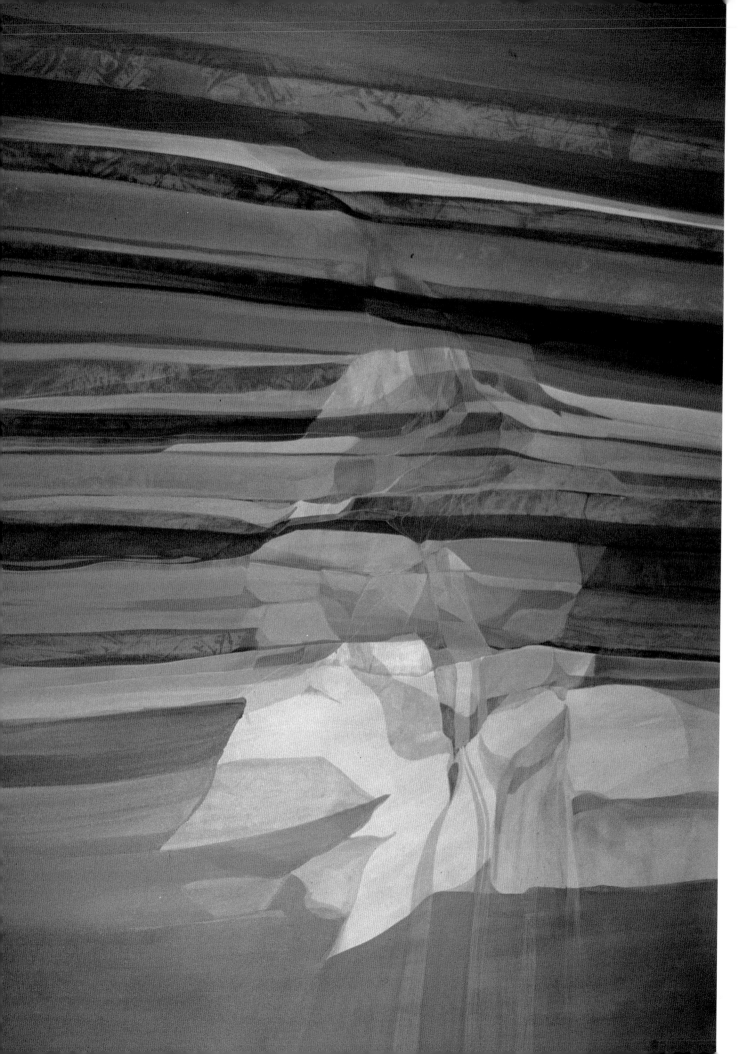

Introduction

For the artist every painting is a one-time experience, an experiment of brushwork, color, and idea. No painting will ever be repeated in exactly the same way because each time you come again to your subject you have changed, your responses to the subject will be different, and your painting will be determined by these new responses.

Painting is an outer expression of the inner self. We each come to painting from a unique place and our views and perceptions of the world are specific to the individual, tempered by our life experiences.

The personal element of painting, that which is the content of our work, cannot be taught but must be learned in a spirit of free discovery. By painting "watchfully," by tuning into the inner self while painting, we learn from the process itself.

This book is written in that spirit of free discovery. An outgrowth of years of teaching an experimental workshop, it is designed to encourage you in the search for a more personal form of expression.

Part One, Searching for a Personal Vision, explores the question of what is real to an artist. The unique and subjective nature of our images is the clue to discovering the inner-eye view that allows our paintings to be a fresh expression of our own experiences.

An artist's vocabulary for expressing ideas and feelings are the tools of design and technique. Before you can work effectively with these tools you must learn to use them playfully, to explore all the directions they can be pushed. Then it becomes easy to discipline them, to make them behave, to control and be relaxed with them.

My own experiments with painting tools began in my mother's studio when I was a child. Because paints, papers, and brushes had been my childhood toys, they became a natural means for my artistic expression as an adult. As a child, I was always encouraged to believe in my experiments as valid forms of art and in my ideas as worthy of expression. My mother was the first of many fine instructors, and she remains a major influence on my work and my life.

Later, classrooms and libraries were an essential part of my art education, but the early playful experiments with painting ma-

CANYON WALL
WITH DOVE,
watercolor and
acrylic on 4-ply
museum board,
60" × 40"
(152.4 × 101.6 cm).

terials freed me from the restrictions the educational system so often imposes. More importantly, I learned at an early age to believe in my own solutions to problems.

Because I work experimentally, no one painting is seen as a final statement; instead, each is a stepping stone that carries me to the next, and all are seen as part of the process of art-making in my life.

Through this book, I hope to pass the results of my experiments with materials on to you. I also want to encourage you to come up with your own unique solutions to problems, your own personal discoveries, your own vocabulary of expression.

Experimental painting requires the same fine-tuned sense of design as traditional painting. By working inventively with design and challenging established rules of what is acceptable, by seeking new symbols for defining an ever-changing life view, you can keep your work vibrant and growing. In Part Two: Designing the Painting Surface, you will learn guidelines for refining painting surfaces and controlling the two-dimensional space.

Technique is another tool—but it is only a tool, a means to an end, a way to greater personal expressiveness. By experimenting creatively with unexpected tools and ideas you will bring a new excitement and challenge to your work. I'd like you to try the series of exercises in Part Three: Enriching the Painting Surface. Each exercise will introduce you to a new method of building a textural surface for your paintings, to help you to achieve a more painterly quality.

The final section, Part Four: In the Spirit of Discovery, examines through a question and answer format, the nature of creative process and gives you guidelines for entering competitions and critiquing your own work objectively.

I once taught a workshop in Rockport, Texas, and at the end of class one of the artists came up to me and said, "The most important thing I learned in this class is that we all have more or less the same tools, and have access to the same sources from which to paint. The only thing I have that no other artist has is *me*." It is this belief in self as artist and author of the image that I hope to encourage.

—Virginia Cobb

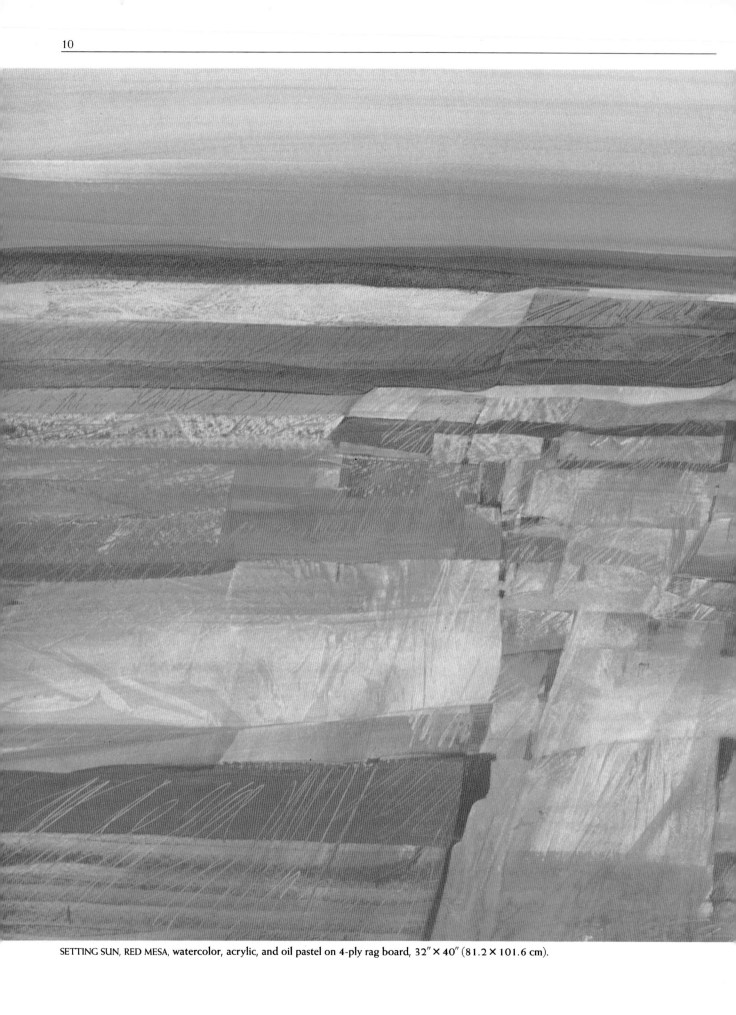

SETTING SUN, RED MESA, watercolor, acrylic, and oil pastel on 4-ply rag board, 32″ × 40″ (81.2 × 101.6 cm).

Part One

THE SEARCH FOR A PERSONAL VISION

*"The moving toward one's inner self
is a long pilgrimage for a painter.
It offers many temporary successes
and high points, but there is always
the residuum of incomplete realization
which impels him on toward
the more adequate image."*

—BEN SHAHN

What Is Real to an Artist?

Our search in art is not for subject matter, it is a search for authentic vision. Since no two of us will follow the same artistic path, it is helpful, once in a while, to stop and review our work, to mark our path, and follow it back to its beginnings, to trace the progression of our thoughts, and to watch the growth and development of our art.

The first time that I set about reviewing my work in depth occurred after I had overheard the following conversation at an art show: Two well-dressed women were standing in front of a large painting that was suggestive of a landscape, but its specific forms were not clearly defined. One of the women liked the painting a great deal and was emoting at length about its exceptional beauty. When she got no response from her partner, she turned to her and demanded, "Don't you just love it?"

The other woman obviously did not, but she was reluctant to hurt her friend's feelings by saying so. Her answer, when it came, was cautious. "Well, it's very nice, but I prefer the ones that are *real.*" As artists, these words— *real, realist, reality, realism*—are ones we all hear a lot, and they always bring back to me the question of what is real to an artist. For art is not an imitation of some predetermined reality, it is a discovery of reality. I don't know anything more real to an artist than his or her own paintings. The images, regardless of whether they are literally represented, abstracted from a subject, or taken from the artist's inner sources, are images that come from our sense of reality in the world. Artists are visual people, and we are influenced by our environment, either directly or indirectly. The colors and forms we carry in our mind's-eye memory appear and reappear throughout a lifetime of painting, and become the thread that ties together our life's work.

Our reality of the image comes from within ourselves and is influenced by a lifetime of experience. We recognize objects and assess circumstances in the light of those impressions of experience. Who I am influences what I see, and how I respond as an artist. My paintings are a synthesis of my outer stimuli and my inner need to express. In transposing an image to paper, I often come to a better understanding of my relationship to what I have seen.

EACH PERSON SEES DIFFERENTLY

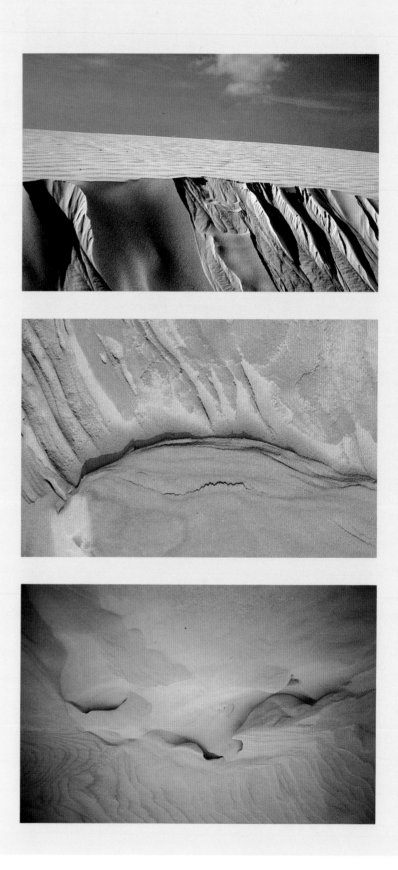

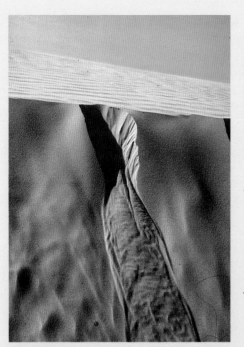

These photographs were all taken on the same day, in the same place, and at the same time. But they all reflect the individual viewpoint of the artists who took them. The first row is the work of a photographer interested in strong mood and dramatic imagery. The second row of photographs was taken by an artist who saw the dunes more as a two-dimensional patterned surface. My own interpretation, evidenced in the third row, shows the dunes as fluid, rhythmic formations that to me are suggestive of movement in time.

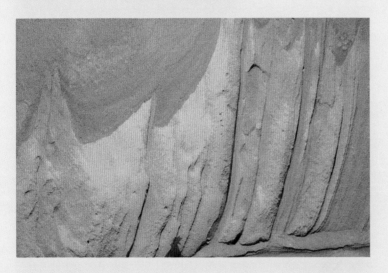

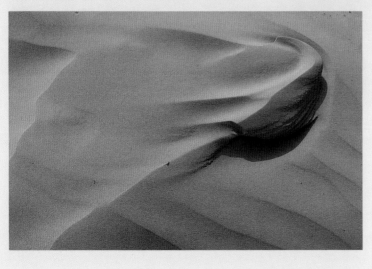

The Lens of Individual Temperament

A graphic example of how differently we each view and respond to our surroundings is made by the following photographs of the Padre Island sand dunes, taken by three friends on a sunny afternoon in spring. The three of us, two painters and a photographer, each found a different fascination in the dune structure.

We spent a long and lovely day there and our mood was one of sharing. Each of us pointed out special areas to the others, and yet no two photographed the same scene. The photos are as individual as we are ourselves.

Bob Bluntzer, the photographer of the group, loves the isolation of the dunes and spends his mornings on the island photographing the sunrise. He captured a dramatic view of the dune that emphasizes the feeling of solitude he sought in this beautiful place. Bob said, "The only thing better than coming here with friends is to come alone."

Polly Hammett, a painter, photographed the dune as a flat surface by emphasizing its stark two-dimensional patterns. And my own photographs were of the flowing, rhythmic formations created by the winds—movement in time.

After seeing the photographs, Bob said to Polly and me, "Now I understand better why you two paint so differently—you *see* differently!"

We all see differently, and as artists we spend our lives searching for an expressive form that allows us to affirm those differences.

"In the arts, particularly painting and poetry, the self is content . . . it is perhaps object and subject in one image."
　　　　　　　　　　　　　—BEN SHAHN

Painters experience growth cycles as they progress throughout a life's career. In reviewing the work of any significant artist, it is possible to follow the thread back to the beginning and weave together the forms that have recurred throughout this process.

In looking back over my own work, I find every life change has played a part in the growth and change of my paintings; each move has added new dimensions of expression to my work.

YESTERDAY, watercolor on fiberglass paper, 22″ × 30″ (55.9 × 76.2 cm).

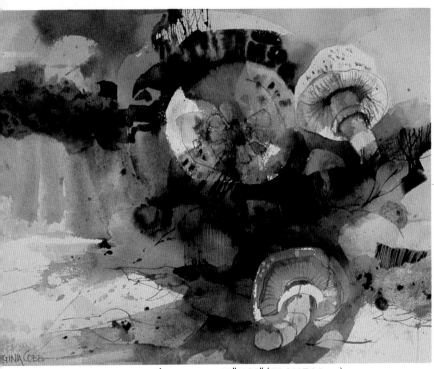

TOADSTOOLS, watercolor on paper, 22″ × 30″ (55.8 × 76.2 cm).

The Visual Painter

In my early days of painting I was strictly a visual painter, responding to my environment in a very literal manner. My Colorado studio overlooked the distant vista of mountains, yet I chose to paint mostly close-up views of my subjects. A large-scale view of the magnificent landscape did not tempt me. For some reason I was better able to relate to smaller and more intimate subjects.

I often like to paint objects that I can literally hold in my hand. Somehow, holding and touching an object makes it more "real" to me, more understandable, more paintable.

Later on, working with the simplified shapes created by the shadows on the walls of the canyon near where I lived, I learned to abstract my view, to search for most important elements of my form, and to define the textures and patterns nature has imprinted there. The series of rock paintings I did at this time is an example of how one simplified element—a rock—can suggest the larger forms of the landscape.

By studying natural forms, I developed an understanding of their growth cycles and intricate designs. As I analyzed the rhythmic patterns in each form, I tried to translate that rhythm into an image. Sometimes the form itself is completely incorporated into the painted surface. For example, the specific textures, colors, and forms of a butterfly's wing would become the abstract basis for a painting's overall design.

Although most of the paintings you see in this book are very realistic depictions of what I saw as the natural world, I am often asked of a painting: "What is it supposed to be?" At first I was flustered by such remarks, and it took a while for me to learn I had not failed because the viewer did not understand the meaning of my work. I had to realize that a painting is a complete entity in itself, with a life of its own; and that art is a poetic, personalized description of an image; it is *not* a duplicate of something else.

PAPILLON, watercolor on paper, 22″ × 30″ (55.8 × 76.2 cm).

WINTER INHERITANCE, watercolor on paper, 22″ × 28″ (55.8 × 71.2 cm).

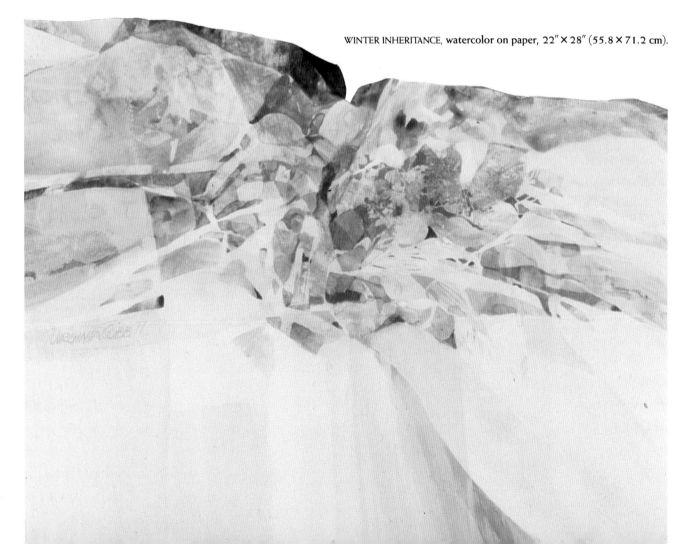

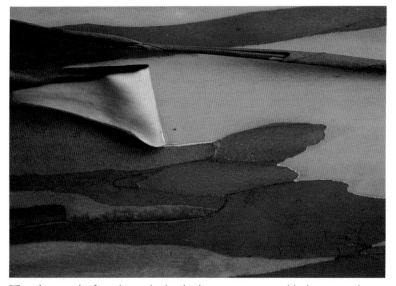

This photograph of eucalyptus bark asks the viewer to stop and look again and question. If you were asked to paint bark, is this what you would envision?

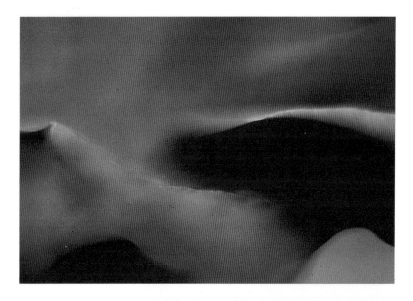

Both these photographs are close-up views of flowers, but neither could be called realistic images. If you chose to define these pictures in musical terms, which one would you call "ballet" and which "fiesta"?

The Camera's Eye . . . The Artist's Eye

The camera's eye and the artist's eye differ because in one case the image recorded is reproduced mechanically and factually; in the other the image is tempered by the personality of the individual.

Most people will accept an abstract image from the camera more willingly than from the artist. Is that because we consider a mechanical device more trustworthy than the human eye? We have been led to believe that what the camera tells us is true because the camera has the singular ability to reduce an image to a safe, literal one that can be interpreted by everyone in more or less the same way. Although the camera's view can be as expressive and undefined as any painting, it most often does not demand any creative involvement from the viewer.

If you believe only in that which is obviously visible, you are settling for surface reality and missing the deeper meanings. Life is filled with images that ask to be interpreted and some that leave us with questions. The eye receives an image and the brain must base its interpretation on information collected from our life experiences. Self is the ingredient that separates your perception of an object from that of another person's.

In art the viewer is part of the process, and as painters our representation of our chosen subject should challenge the viewer's eye. Artists should raise questions in the viewer's mind, not answer them so that there is no sense of wonder left when viewing our work.

If we put too much information into our paintings, and leave no questions, we leave nothing to involve the viewer's active imagination; we have taken away his or her role in the art process.

When we are children we do not doubt the reality of our images, but as we grow in experience, we become so influenced by what others consider "acceptable" that we tend to lose confidence and allow others to determine for us what is beautiful or credible or real. As adults, it takes courage to believe in our own images, our sense of the real, which is the content of our work.

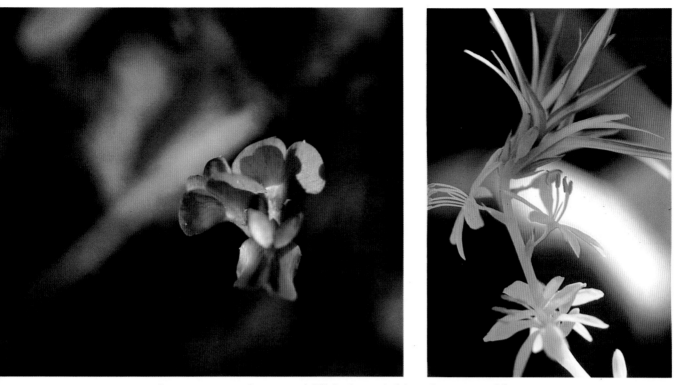

Some images are easily interpreted. The background of the violets is easy to define because the forms and colors are related to the subject. By contrast, the background of the white flowers does not tell us what it is; it leaves the interpretation to our imagination.

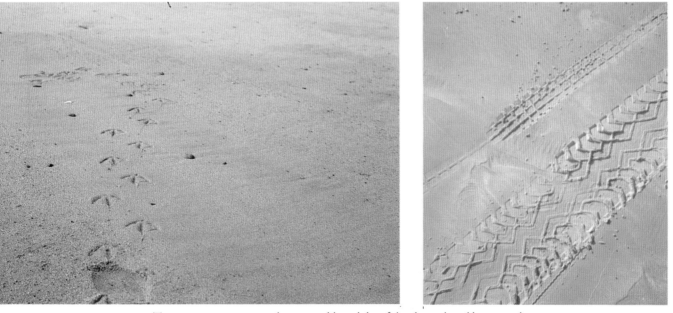

To interpret some images, only a general knowledge of the physical world is required. Ask yourself: What kinds of creatures passed by here?

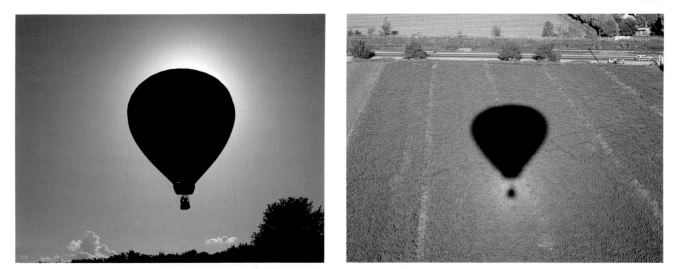

Ask yourself: Where is the sun and where is the viewer in these photographs? The sun and the viewer are not visible; you simply understand that they exist.

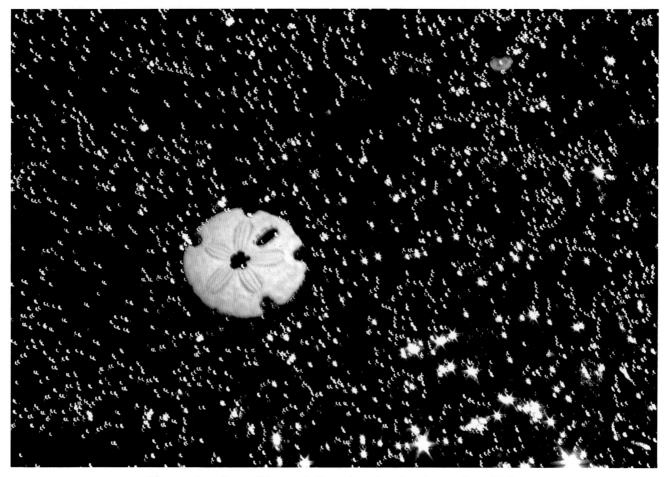

Often something that could be passed off as ugly at first glance becomes beautiful if examined closely. The reality of the subject is in the interpretation. This beautiful photograph of a sanddollar was taken on a day when the beach was sullied with an oil slick.

Our perceptions are formed by our experiences just as the land is formed by time and the elements.

The viewer is different each time he or she is exposed to a work of art. A person, like the proverbial stream, is never the same twice. As artists, no two of us perceive a subject from the same vantage point.

REALITY IS AN ILLUSION

As expressive artists we are free to choose and define our reality of the subject. The idea of a fixed reality is an illusion, like shadows and reflections.

WHAT COLOR IS WATER?

When I was a child a teacher told me that water was blue. Since then, I've found that it takes courage to believe in my own images, my own sense of the real.

Authentic Vision

Visualization: picturing, imaging, calling forth from the mind's eye, evoking a mental image, portraying or representing in the mind.

In art, we begin with the process of visualization (a mental image). Whether a well-formed image or a vague one, our visual images are unique to each individual. In my search for a personal artistic vision, I have tried to allow changes in my work to occur naturally, as they would in any growth process. With each life change, there is a shift in color and form—sometimes subtle, sometimes dramatic.

The emphasis of my work shifted after I moved from the mountains of Colorado to the inner city of Houston, Texas. Painting in an urban environment felt very closed in and unnatural to me. For a time, I worked with circular designs, using shapes that had a closed-in feeling. One series of paintings, called *Nesting*, was indicative of the time in which I was trying to create a place for myself in a new and unfamiliar setting. Being a nature painter in the inner city pushed me to find new ways of relating to my subject.

As I continued to work in this new environment, I began to look more within myself for the meaning of my subject and less to the visual characteristics of the object. I found that I could paint the same subject numerous times, but that I would respond to it very differently each time I came back to it. Each interpretation of the subject was unique because each experience had been different. There is a Zen saying that I believe holds true in art: "Everything moves and you can never step twice into the same stream."

NESTING, watercolor and acrylic
on 4-ply rag board, 32" × 40" (81.2 × 106.6 cm).

To create a more natural environment for myself, I filled my studio with stones, shells, and nests, and based my Nesting series on these images.

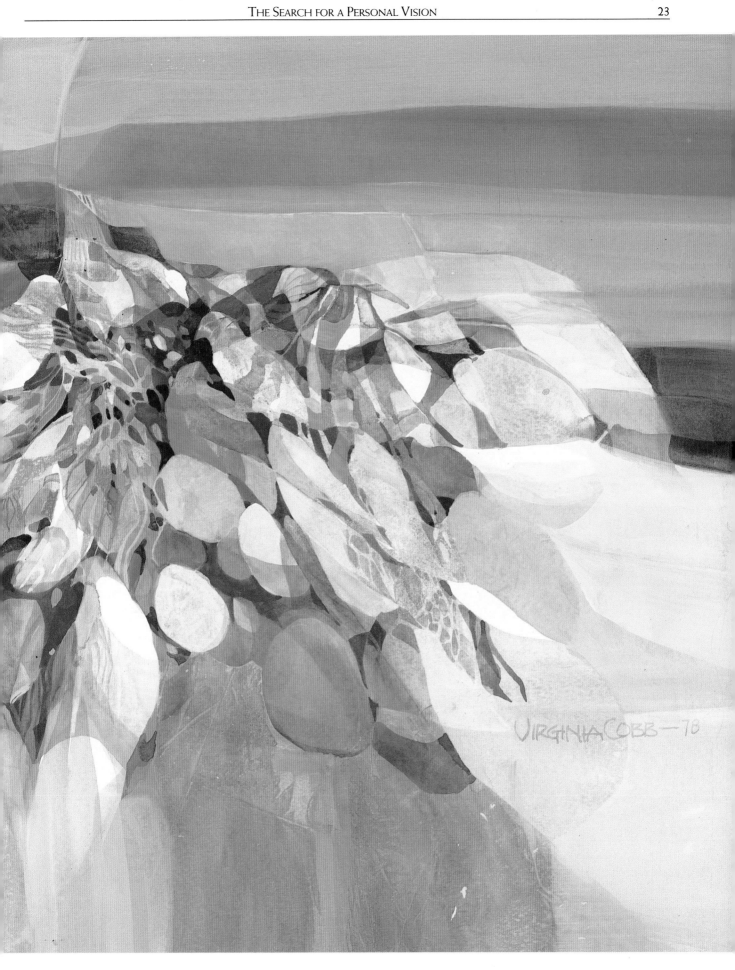

Photograph of rust textures

UNIVERSE,
acrylic and collage,
on 4-ply rag board,
32″ × 40″ (81.2 × 101.6 cm).

I experimented with textural effects, using
magnified photographs, to see how
closely I could approximate the texture of
rust, stone, and weathered wood.

Photograph of a flower

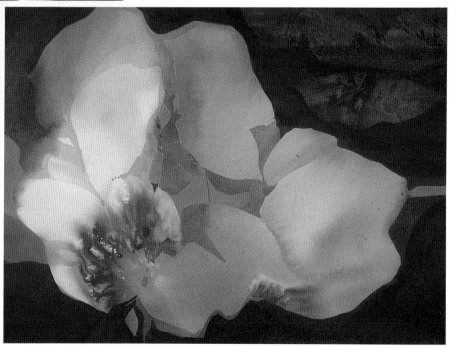

NIGHT BLOOM,
watercolor on paper,
22″ × 30″ (55.8 × 76.2 cm).

Although I seldom work directly from
photographs, I do like to use them as the
initial stimulus at the beginning of a
painting. For me, the joy of painting is in
freeing myself from any preconceived
plan, which allows me to finish the work
more creatively.

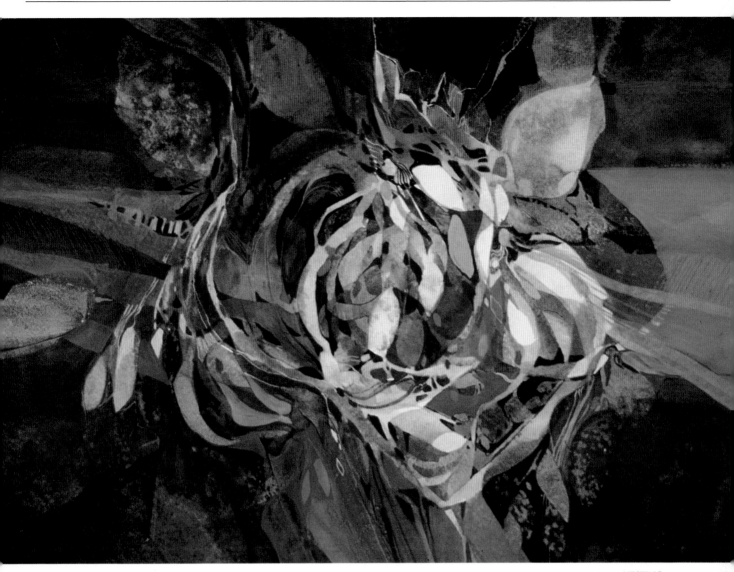

NESTING 6,
watercolor and ink on paper,
22″ × 30″ (55.8 × 76.2 cm).

The surface for this painting was one of several prepared sheets of rag paper based on the colors and textures of a rusted gear-wheel. Later, I decided to use its rust textures as an underpainting for the more organic forms of nesting materials.

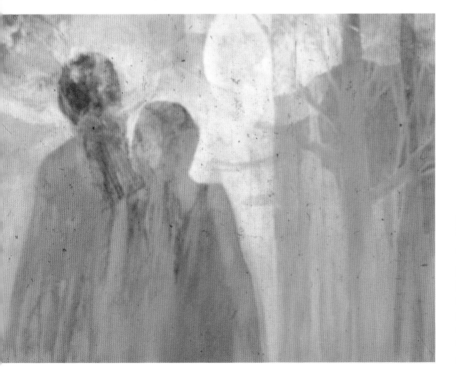

SISTERS, watercolor and collage on paper,
22″ × 30″ (55.8 × 76.2 cm).

This painting began with a drawing of a white iris juxtaposed with a white fence, but by mid-painting the image had evolved into two figures that suggested an image I had of my sister and me at a young age. I was always the small one trailing along several steps behind. The thrust of the shoulder of the smaller figure is a very familiar stance for me, even now.

Using Natural Forms as Subject Matter

It is important for me to retain a personal element in my work through the process of experimenting with new materials. Because I work experimentally and am often changing the technical direction of my work, I have found it helpful to use familiar subjects with which to experiment with new ideas and techniques.

Any natural form, no matter how small, contains all the rhythmic patterns of its surroundings and is, in essence, definitive of the entire landscape. This more universal view of natural elements has expanded my thinking about the relationship of natural forms to each other, and my relationship to nature as my subject.

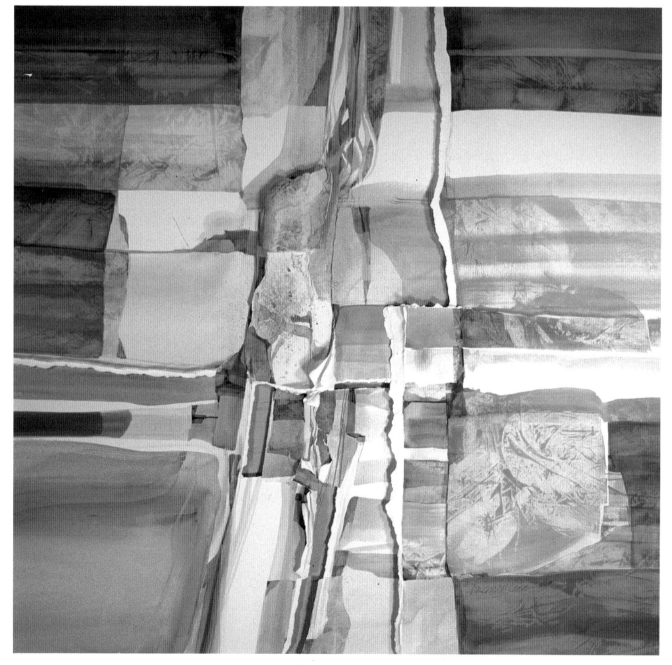

CANYON WALL 6, watercolor and acrylic on 4-ply rag paper, 40″ × 48″ (101.6 × 121.9 cm).

Paintings based on canyon images have been a continuing theme throughout my painting career. In my early painting days, I lived at the entrance to Clear Creek Canyon, and it became my teacher. Working in my studio, I painted the canyon by looking at the stones I had brought back from the canyon floor. In this way I discovered that the stones themselves were descriptive of the entire canyon wall.

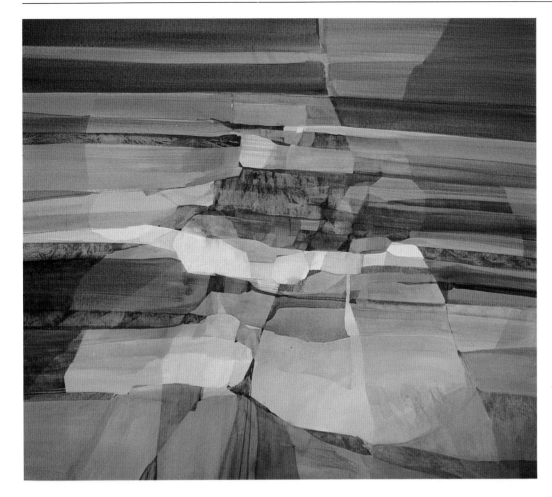

CANYON WALL 8,
watercolor, acrylic,
and stone on 4-ply
rag board, 32″ × 40″
(81.2 × 101.6 cm).

*In 1980, I began what
was to become a series
of constructed paint-
ings, in which I cut
away a section of the
painting surface with
an inlay of sliced stone.
Then around this piece
or pieces of actual
stone, I created the look
of a canyon wall
using the textures and
designs that were in-
spired by the stone.*

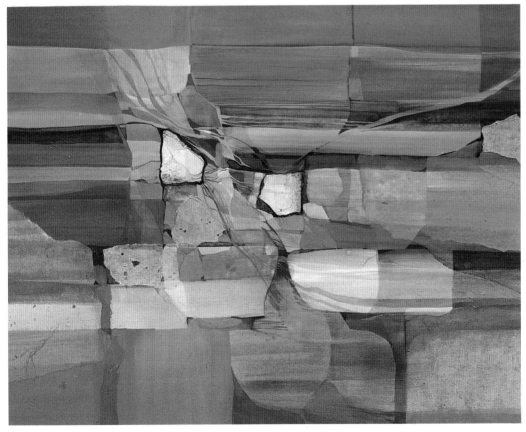

CANYON WALL 14,
watercolor, acrylic,
and stone on 4-ply
rag board, 46″ × 46″
(11.8 × 116.8 cm).

*In an effort to build the
layers of form-on-form
so evident in the walls
of the canyon, I began
"breaking" this painting
apart and reassembling
it in layers.*

Trusting Your Own Point of View

Through the years painting has been my way of identifying my place in the world, of allowing me to get in touch with a sense of self, whatever my environment. A move to New Mexico in 1985 brought me back to more natural surroundings. During the transition I began a series of paintings that I call *Journeys*. In each of these paintings, there are areas of the landscape deliberately displaced, and in each a bird in flight—symbolic of myself in motion between two worlds.

I have outlined the evolution of my work as a painter in an effort to give a background that defines my work today, in the hope it will help you have a better understanding of your own evolution as a painter and possibly give you the courage to seek more personal forms of expression.

One of the major breakthroughs that an artist makes is to learn to trust in his or her own point of view and to believe in his or her own expression. It is not necessary, or even wise, to follow prescribed methods. But it is required that you approach your work with confidence in yourself as author of your own image. By expressing yourself in a personal way you evoke a response in the viewer. In effect, you create a true audience for your art.

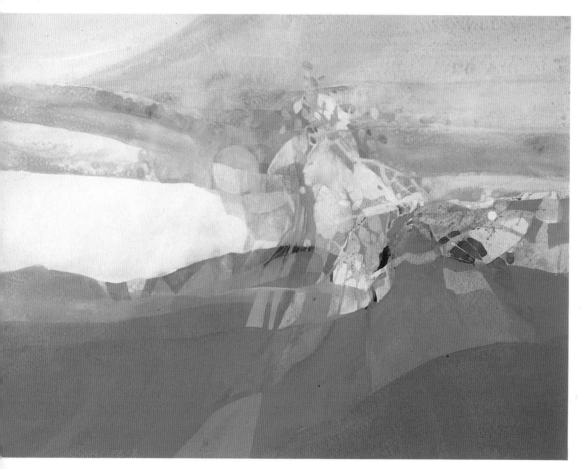

CHRYSALIS,
watercolor and
gesso on paper,
22″ × 30″ (55.8 × 76.2 cm).

This painting is a self-portrait. The figure is part person, part bird, and part butterfly.

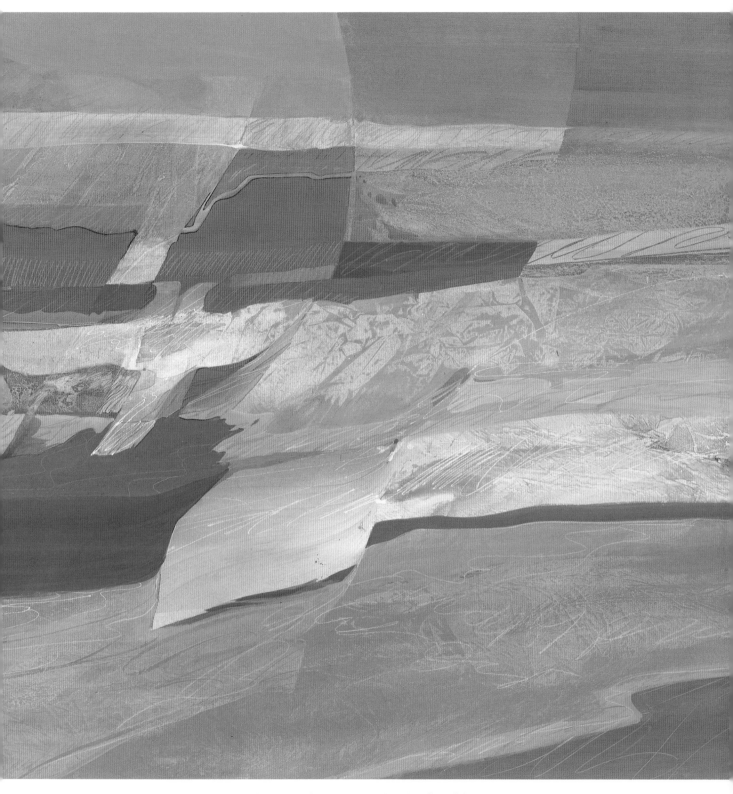

JOURNEYS 7, watercolor and acrylic on 4-ply rag board, 32″ × 40″ (81.2 × 101.6 cm).

The Journeys series was painted during the transition period of my move to New Mexico from Houston. They still carry the strong abstract influence of the urban paintings but signal a move toward the new landform paintings.

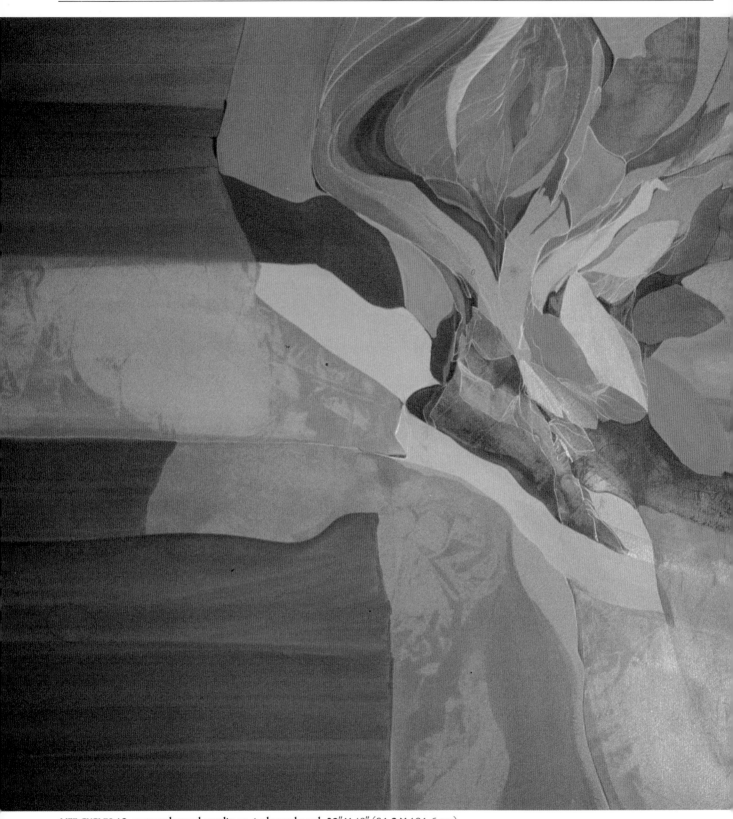

LIFE CYCLES 12, watercolor and acrylic on 4-ply rag board, 32″ × 40″ (81.2 × 101.6 cm).

Part Two

DESIGNING THE PAINTING SURFACE

We are constantly striving for that sense of centeredness in all of life, for a perfect balance that allows us to move with grace, to be one with our surroundings.

The Dynamics of Design

Painting is merely a dance performed on paper. All the elements are there: the flow of the music, the rhythmic patterns, the twists and turns. When you are caught up in the creative process you can almost see the dance.

When we design we seek a perfect balance, a centeredness. Within our own nature is a perfect centeredness available to us at will if we tune into it—if we listen to our own pulse. When I say "centering" I am not describing a work of art that is static or that has its focal point in the center of a composition but rather a fluid piece that has an intrinsic grace and a perfect balance.

We are constantly striving for that sense of centeredness in all of life, for a perfect balance that allows us to move with grace, to be one with our surroundings. The athlete understands that need to center himself or herself in order to achieve the highest level of performance. The golfer "centers" before swinging the club; the tennis player shifts from foot to foot seeking "center" before making a serve; the dancer must reach that point of perfect center before attempting the *tour de l'aire*.

These artists understand that while they must know all the rules and guidelines of their art, and practice them with regularity, when it comes time for the event they must rely on their innate sense of accuracy and their ability to "feel" balance and spatial harmony.

The only thing that separates painting from performance art is that a painting lingers on to haunt us if we miss a beat and it is not perfect. But as visual artists, we have the advantage of being able to make alterations.

In designing your painting you are reaching for that center, whether you are aware of it or not. And it is when we develop an awareness that we learn to design with an intuitive sense. We weave together the elements of design with the theme, or content, of the painting, creating the whole fabric of the piece.

By studying nature, you can better understand how design works. A single flower on a long stem that seems so weighty that it cannot possibly stand—yet does—turns and shifts its weight subtly to accomplish the impossible.

In designing a painting we are also shifting weights, colors, values, lines, and forms to center the composition. For example, if a weight, or element, is deliberately placed far out of balance, it can be countered with a precisely placed subtle point of color that will shift the balance back to center; or a shape can be tilted in such a way that its own weight

centers the composition and brings the design back to a balanced one.

Like the dancer, we must practice our art to sharpen our skills. We must be willing to spend time and energy "playing the scales" of technique, "stretching the muscles" involved in learning to design with grace. We must not expect so-called successful results from every painting effort, but must be willing to consider some painting time as learning time. Each session of time devoted to practice increases your understanding of your skills, allows you to give yourself more freely to expression with your medium. The time spent in practice is time spent integrating your creative artistic nature with your more analytical, mechanical skills, the side of you that creates with the side that designs.

Design is the inner critic at work. We each have a built-in sense of what good design is. This sense comes from observing nature, observing works of art, and from working with our paintings. But often when a painting does not work the reasons are unclear. We might know instinctively where the problem area lies, but we don't know quite how to solve it. By experimenting with design problems that have no fixed solutions and exploring the many possible variations on a theme, you strengthen your intuitive knowledge of design and consequently you train your inner critic. This knowledge allows you to use your design skills more decisively.

The design of a painting is not content. And while it is helpful to have a clear understanding of design principles, we as artists must be free to explore new methods. In painting content is the active involvement of the creative self. There are no fixed rules that can be applied to art because the content in each individual case will have a unique set of needs. If we are alert to those needs they provide the clues to designing more interesting work.

Your interpretation of a subject or theme is governed by your own unique personality traits. While I may view the long-stemmed rose as a lovely gift significant of joy, you might see it as one more hay fever attack. My painting of a rose would necessarily evoke a different mood than yours. It is by listening to our own inner voices that we are able to move away from painting that is merely visual representation and into painting that is artistic interpretation. It is our inner responses that dictate the dynamics of a work of art.

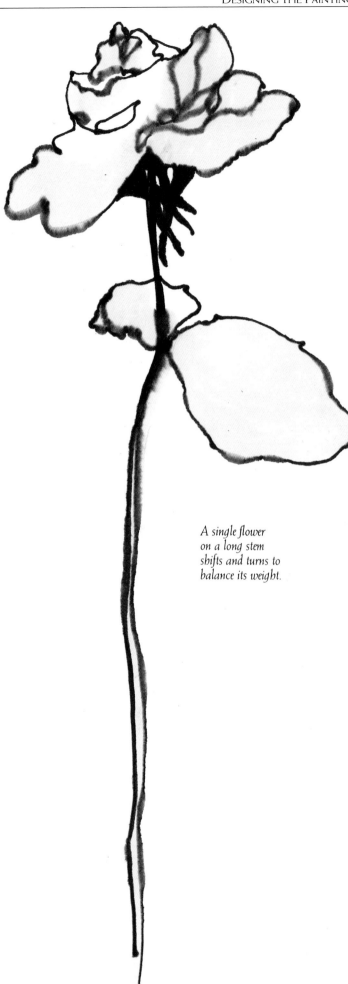

*A single flower
on a long stem
shifts and turns to
balance its weight.*

Experiments in Design

The exercises that follow are intended to help you gain confidence in planning and controlling the relationships of elements found in your paintings. These relationships—both of shapes to each other and to the two-dimensional space—are the key to making paintings that successfully achieve a design balance.

This part of the book is divided into five basic areas:

Designing with Shape

In this section you will explore shape relationships by examining how shapes affect each other as well as the total space when they are isolated, linked, or overlapped. Using one shape, you will render it from different viewpoints to see how each changing perspective alters the interpretation of your subject.

Controlling the Visual Space

Here, you will examine the various methods available for manipulating the painting surface. These include changing scale, focus, perspective, and visual rhythms.

Mood as Content

This section demonstrates the ways in which mood affects design. By moving design elements up and down the mood scale from calm to agitated, you can learn to work with the emotional dynamics of your painting surface.

Idea and Image

The concept behind a painting has a strong impact on its design. In this section you will work with designing conceptual paintings using humor and surprise as the content. Both humor and a sense of surprise can be used effectively to involve the viewer and to communicate ideas better.

Breaking the Rules Successfully

This section is meant to help you to challenge the established rules of design and to motivate you toward more creative design solutions. In the suggested exercises, you will begin to design a painting by breaking an assumed tenet of so-called good design. Through counterbalancing manipulations of shapes and materials, you will learn how to take a more creative and less rule-bound approach to art.

Designing with Shape

Whether you work figuratively or nonfiguratively, literally or abstractly, you are working with shape relationships. It is sometimes hard for a more literal painter to separate from the subject enough to think of his subject as shape rather than object. However, it is valuable to learn to flatten the object in your mind's eye and work with it a few times as a simple shape in a two-dimensional design. When you return to your more representational work, you will find you have a stronger sense of how to relate the subject to the painting surface.

If you are used to working abstractly, the following design problems will be helpful in developing a stronger understanding of overall relationships within a painting.

Begin with a shape you can see while you are working, something you can carry into the room, such as a nest, a stone, a shell, an apple, or something from your work table, such as a tube of paint. Choose a form that has an appealing contour or create an interest in the contour by somehow changing it, such as taking a bite out of an apple that has been cut in half, or squeezing out the contents from a tube of paint. This shape will then be the form that dictates your design.

If you don't like working with a literal form, draw a shape on paper and tear it out, or tear a random shape. This will serve nicely as a shape to look at while painting.

Draw the outer contours of your shape with your eye alone, allowing your eye to slowly trace its form. Feel each twist and turn. If you get bored before you have outlined the whole shape, you have probably chosen a shape that will lose its interest when you paint it. I suggest you choose a shape that has more visual interest—boredom shows up quickly in a painting.

Visualize your shape floating in air, disconnected from any context, because in a way it doesn't exist outside itself. The boundaries of your page can only be established when you connect them.

By adding a line that reaches out to touch an edge I extend its physical boundaries. Each time another edge is touched, a stronger design is created.

Think about how a spider spin its web. It creates the parameters of its world by tying down the edges. In essence this is what we are doing with a rectangular canvas or page, creating the world in which our shape exists.

Paint your shape quickly on several pages, placing it in a different quadrant of the page each time. Wash it in loosely with a large puddle of color. This will help you familiarize yourself with its form.

Practice tying it to the page's edges to get the feel of connection. To establish a form that has a particular character, give yourself verbal terms for reference. Sometimes it helps to write descriptive terms on your page, or on a nearby piece of paper. Large gestural designs can be used to break the page into shapes. This group of shapes can be the inspiration for any number of paintings.

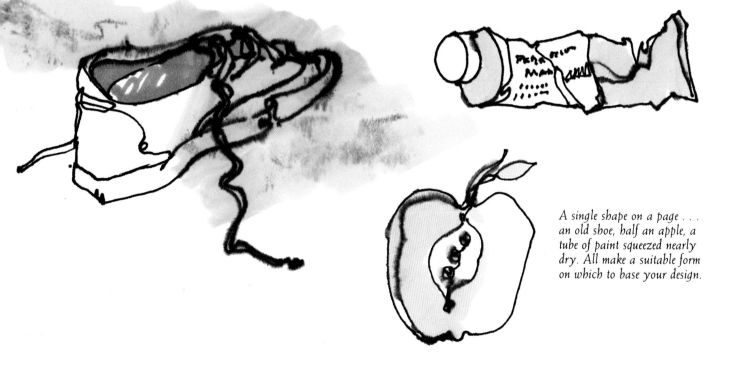

A single shape on a page . . . an old shoe, half an apple, a tube of paint squeezed nearly dry. All make a suitable form on which to base your design.

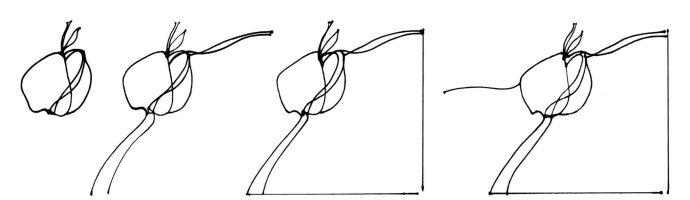

One apple tied to two edges creates its own world.

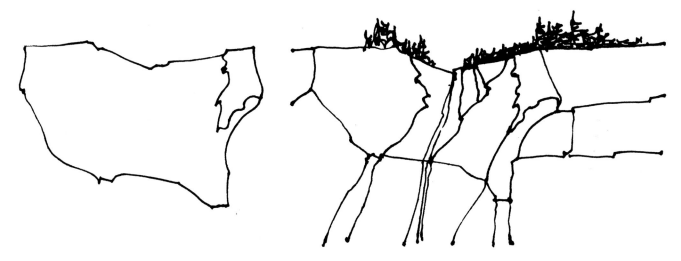

By extending the boundaries of this torn paper shape, a recognizable, natural form begins to emerge. This simple technique gives the shape meaning and creates an environment for the form.

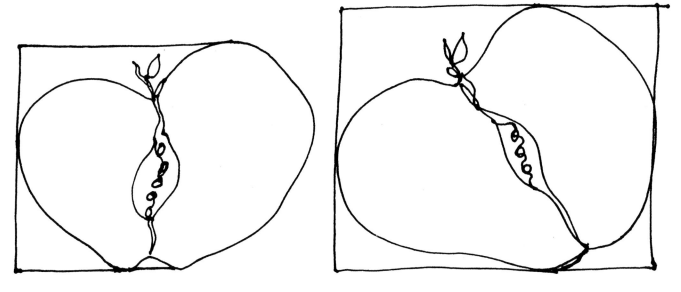

You can exaggerate, flatten, or distort a form by extending its boundaries to a clearly defined edge or edges.

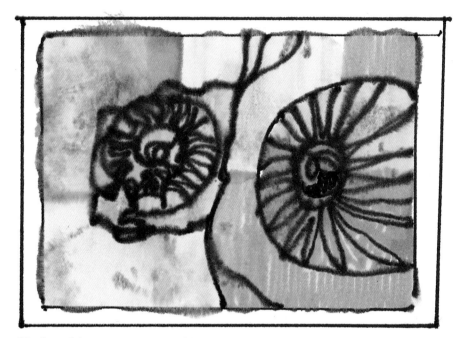

The form of this ammonite is restricted by the shape of the paper it's drawn on. Repeated patterns, textures, and colors were used to create the environment surrounding the shell-like forms.

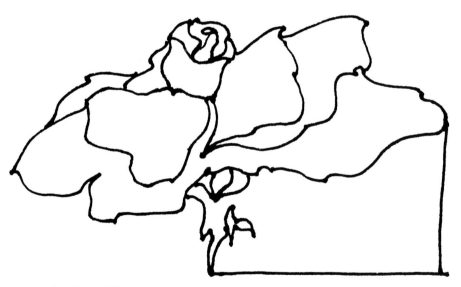

Each form has a different nature. The character of a form is defined by its contour and by the shapes it creates within the boundaries of a rectangle. This flower has a fluid form, suggestive of a dancer centered on a stage.

Each version of this apple required a different treatment. Each one suggests a different rhythm or mood, from lazy to upright to uptight.

Thinking about painting in verbal terms can help you establish the visual effect you are seeking in your design. When seeking energetic line and form, I think of strong, decisive marks, angular and straight.

Curved lines and rounded shapes suggest a quiet rhythmic flow.

If you want to change a drawing's tempo, you can combine two ideas and make them work together. It's a good idea to be aware of combinations such as this happening in your paintings, so that you remain in control of evolving patterns and shapes.

BUILD A PAINTING AROUND A SHAPE

By boldly writing your name across a page and letting it touch at two edges, you will divide your paper into two shapes. You can build a form using the contour that the letters suggest.

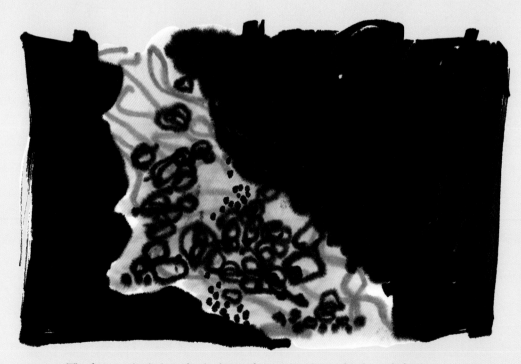

This form can be the basis for the design of a painting. It can then be applied to any subject . . . pebbles on a beach . . . flowers on a hill . . . a still life . . . a figure.

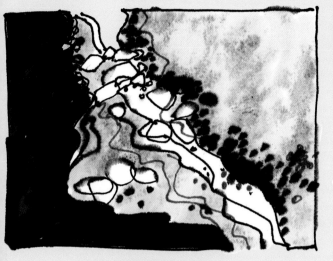

PEBBLES ON A BEACH

FLOWERS ON A HILL

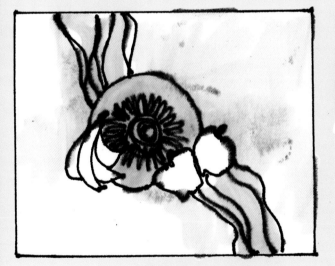

A STILL LIFE

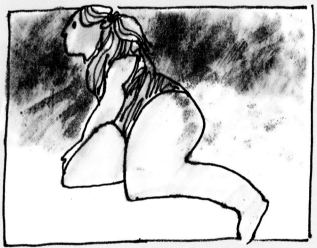

A FIGURE

virginia

The shape and flow of my name written out is not
unlike the contours of the dove that I so often use as
inspiration for my paintings.

CANYON WALL,
charcoal and watercolor
on 4-ply bristol board,
32″ × 40″ (81.2 × 101.6 cm).

This demonstration painting
was done from a quick gestural form
built around the shape
my name takes on paper.

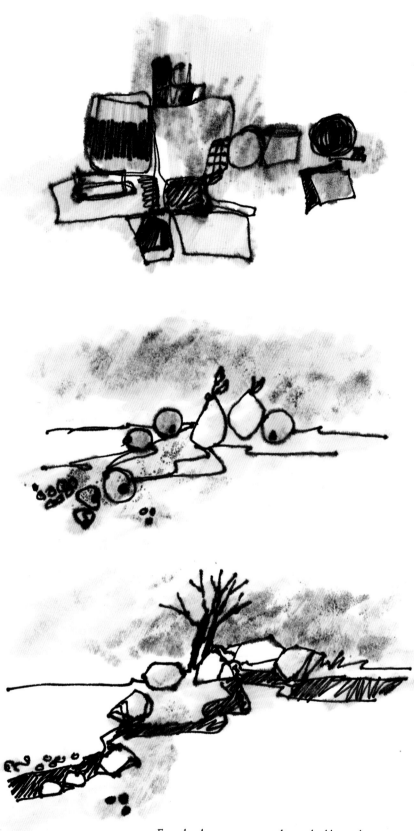

Even the clutter on your studio worktable can be a design inspiration. The same composition can easily be turned into a still life of fruit or a landscape of rocks scattered over a hillside.

Controlling the Visual Space

Creating a painting is like weaving We tie our surface plane together by touching the edges of the page with color, line, and form. When a shape is contained within the page and is not touching any edge, it creates a hole in the surface that is then rewoven by the color and textural threads connecting the shape to the edges. If you think of the surface in this way, it's easier to understand the importance of allowing line, color, and texture to move in and out of the surface.

To experiment with this idea, try weaving color areas together with no subject matter in mind. For your first exercise, use a brilliant dye color for your "warp" (the vertical bands of color) and the more opaque and flat color for your "woof" (horizontal bands). As you work, allow the colors to overlap and neutralize each other, creating areas where you can see through to the color below.

When working with a specific subject, it's effective to experiment with this weaving process by painting in the various textures and colors of the subject throughout the whole design. In this way, you will be exploring all the nuances of subtle change that exist within the subject. Then choose the area that is descriptively most pleasing and isolate the shape of your subject within that area.

Another approach you can experiment with is to weave together contrasting strips of paper or canvas into a pleasing design. Then take that design and make a painting based on your weaving design. An easy way to work with this type of simple grid is to establish a color design that is essentially monochromatic where one color is darker than the other. To embellish your design, an additional third accent color will supply a rhythmic sparkle to your design.

For a less formal type of grid, you could paint a landscapelike design using cool shadowy colors similar to the monochromatic weaving exercise. Allow light-valued patterns suggestive of scattered sunlight to "wander" rhythmically across the page.

As artists, most of us are aware of the importance of interlocking shapes in order to create a more cohesive design unit. You can push this idea further by reaching "behind" the surface plane, so that the eye is pulled into the painting as well as across it. These windows into the painting give the viewer a sense of the organic nature of art, and that this painting has literally grown out of the paper.

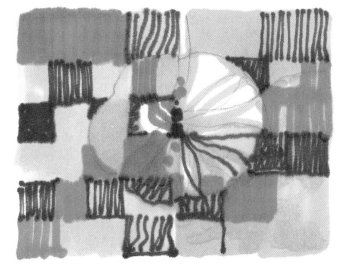

This more or less formal grid is composed of alternating bands of warm and cool color. Note the circular form "found" within the pattern of squares.

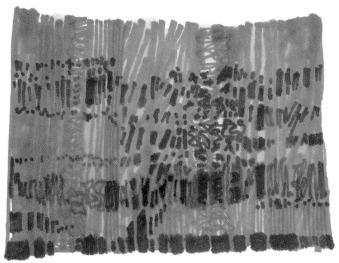

Interwoven strips of flat and brilliant color define this randomly designed grid.

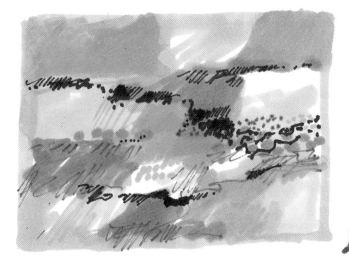

This sketch is an example of a design that is still loosely based upon the idea of the grid. It is composed primarily of soft patches of monochromatic neutrals accented by threads of brilliant color.

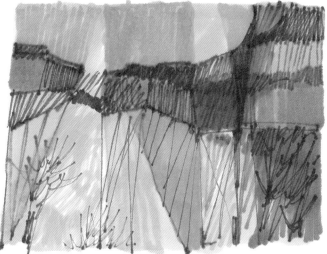

Landscape forms are suggested by this informal grid of warm and cool colors.

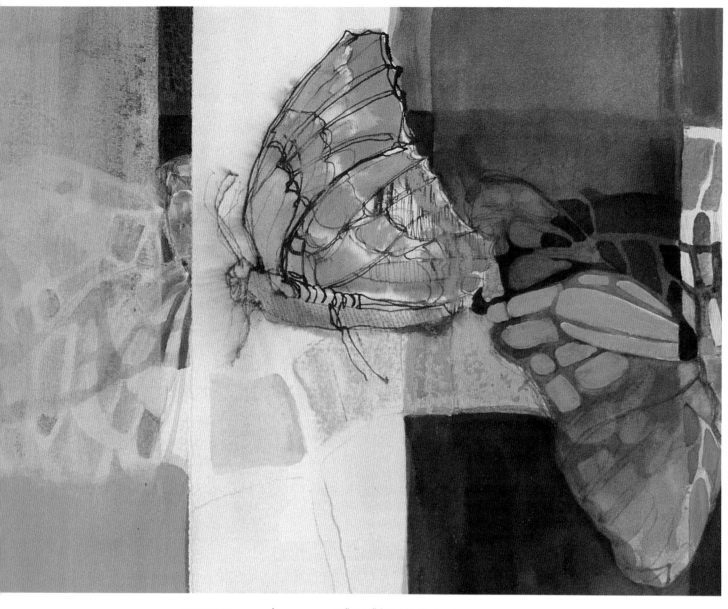

BUTTERFLY, watercolor on paper, 15″ × 17″ (38.1 × 43.1 cm).

In this small watercolor the butterfly form itself was defined first. Then the surface of the painting was created by weaving together the shapes and colors taken from the wing pattern.

APPLE, watercolor, acrylic, and collage on 4-ply rag board, 14″ × 14″ (35.5 × 35.5 cm).

Here the surface of the paper was colored and textured to suggest the form and color patterns of an apple. In the final stages, a layer of opaque color was used to accentuate the actual shape of the apple.

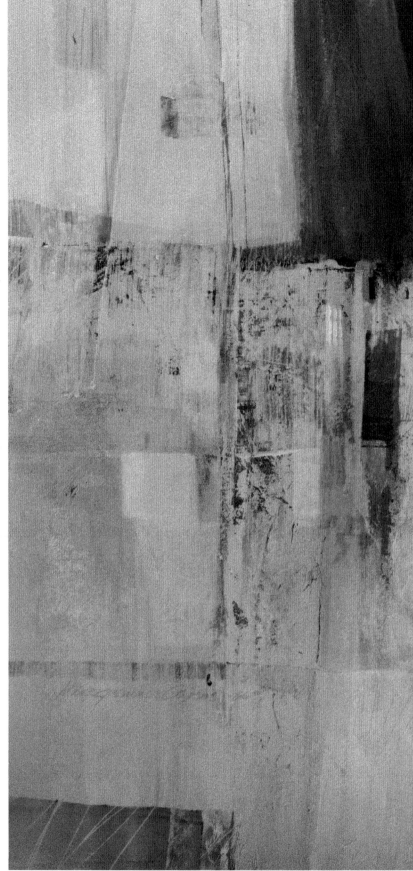

A grid design is an effective device for describing many types of subject matter. Although the viewpoints of these photographs are very different, a grid design could be used to describe either one.

ANCIENT WALLS 2,
watercolor, gesso, and colored pencil on rag board,
32″ × 40″ (81.2 × 101.6 cm).

The blues and lavenders you see in this grid-inspired painting are interwoven with white, which allows the colors to move under and over each other.

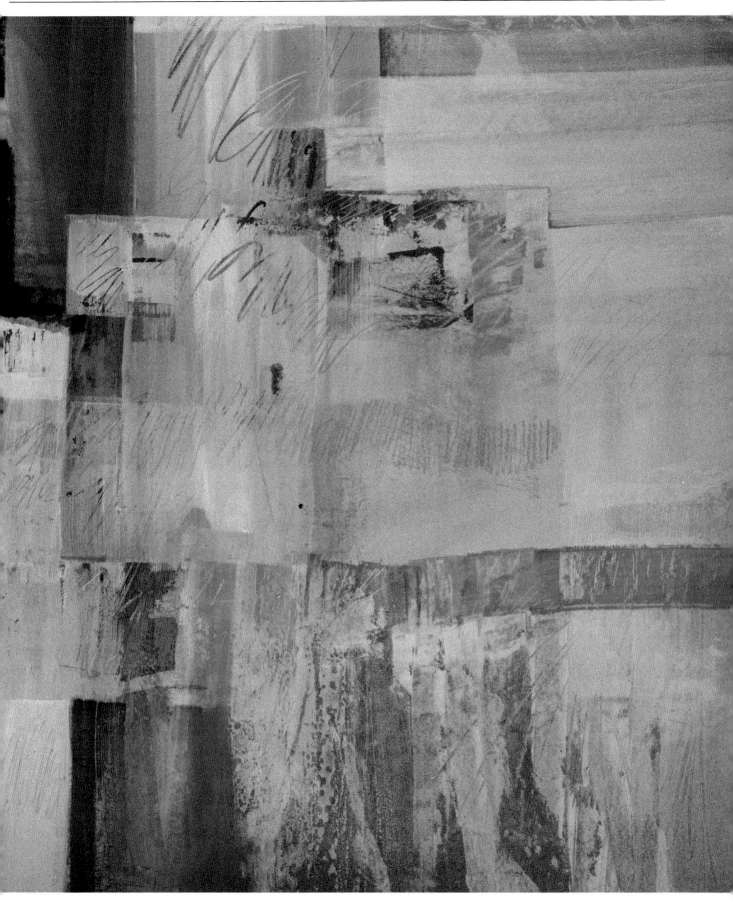

Three Points of View: The Subject in Its Environment

An excellent way to explore designing with a form is to render your form in different situations, from different points of view.

Think of your eye as a camera and focus on your subject from various vantage points. The first painting in this series should be the view that we all accept as "realistic." Place your shape on the page using about one-ninth of the picture plane, and then create an environment in which you might expect to find such an object.

Artistically, our environment can be something as abstract as related shapes or textures,

you the tools to design your painting.

In the first point-of-view sketch below, the subject, although dominant, exists within the context of the environment. In the second interpretation, the form is enlarged and allowed to touch the edges of the paper on four sides, creating a situation where the subject itself becomes the environment. In this type of design the shapes of the negative areas of the page take on an added importance. The treatment that the negative areas are given is flexible because the environment has been established by the dominance of the subject.

A dried yucca seed pod is seen here from three different points of view: In the first sketch (left), the seed pod, although definitely the subject, is just one element in the composition; in the second version (opposite page, top), the seed pod becomes the environment; and in the third version (opposite page, bottom), the seed pod becomes a world unto its own, and the forms found within the shape define the page.

so be as loose in your definition of environment as you choose. I like to work with a natural form for this kind of exercise: a shell found on the beach, a leaf by the roadside, a dried weed pod still clinging to its stem at the end of its growing season.

We have all seen paintings of a singular subject, such as a small still life of fruit, in which the environment, or background, is simplified to shadowy forms. These muted forms tie the subject to the edges of the page. The simplicity of such a design is its strength. But whatever form you choose to use, study it first and identify its textures, color patterns, and definitive lines. These elements will give

In the third view of the pod form, the shape goes beyond the boundaries of the paper. This view forces you to examine the form more closely and find within it the design elements that then become the basis for your sketch or painting. Enlarging the view of your subject this way is very much like viewing it through a magnifying lens.

Interpreting your subject in more than one way is an excellent way to learn about design. It teaches you to think of your form more abstractly and gives you a familiarity with your subject that allows you to paint it more convincingly no matter which view you choose.

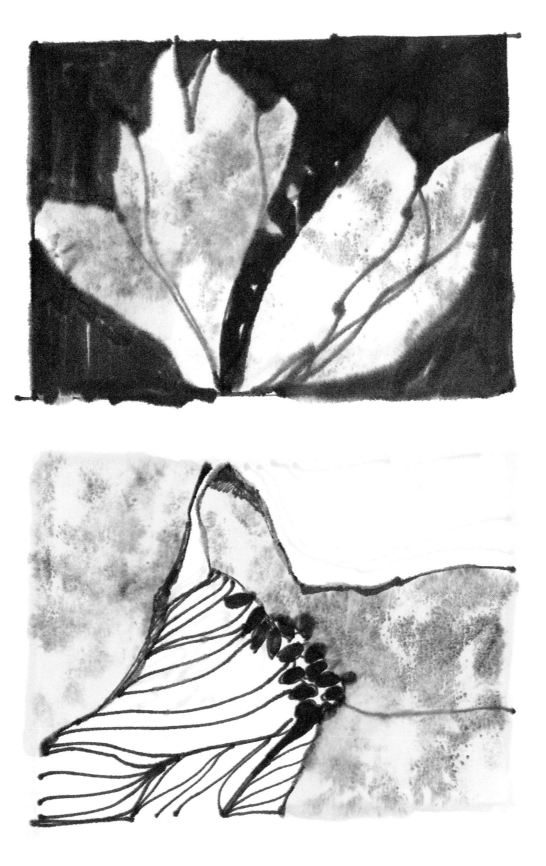

Natural Patterns

The patterns, lines, and textures of natural forms are lovely and intricate. By first studying and then painting a natural object such as a seashell, you will gain a lifetime acquaintance with the forms of the shell. This knowledge can then be translated into paintings of shells or of shell-related forms such as the shape of a shoreline or the curve of a breaking wave. All these water forms bear a similar rhythmic pattern.

At workshops I often hear a participant say, "but I have painted shells before" as if to say that he or she has exhausted that subject. My reply is to inquire how thoroughly the shell was studied. Was the point of view close up or far away? What was its environment—natural or out of context? Only when you have explored a subject thoroughly will you truly know it.

When we look at drawn or painted images, it is most often the edges of shapes that define them to the viewer. You only have to define a few edges for the shape to "read." You don't have to shout for people to hear; if you speak softly they stop to listen.

To test this idea, try painting several versions basing your design on this kind of magnified view. Define your form using only one or two edges to allow the viewer to imagine the complete image. The illusive quality of this kind of handling of a subject will draw in the viewer. I am especially pleased when I hear someone say of one of my paintings, "Every time I look at it I see something new."

As artists, this response is what we all hope for, that once completed the painting takes on a life of its own and continues to be a source of interest or pleasure to others.

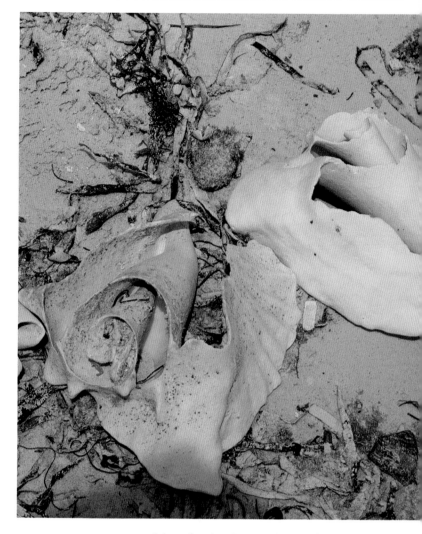

Subjects found in the natural world often reflect an exquisite, miniaturized view of their larger surroundings. These ink drawings of shell patterns seen close up explore this subject's naturally fluid and rhythmic lines. In the wash drawing, the colors and patterns of the shells were used to describe the surf and shoreline of the shell's environment.

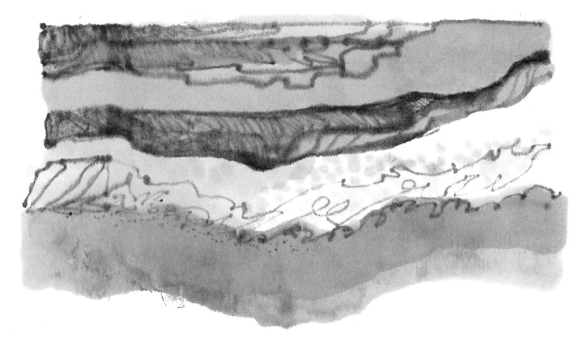

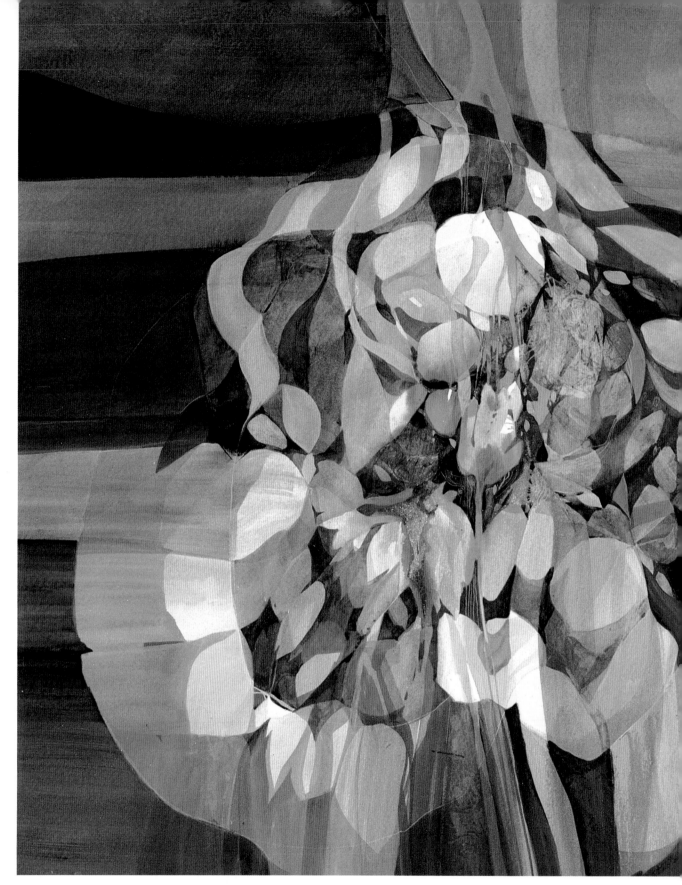

LIFE CYCLES 6, watercolor on paper, 48″ × 48″ (121.9 × 121.9 cm).

This painting was inspired by a small seed pod. Radiating in ever-enlarging shapes from the center, the pod patterns and colors create their own environment.

Designing with Repeated Shapes

Using repeated shapes in your painting is another way of designing with shape. Japanese screens are magnificent examples of this kind of design, in which the viewer is drawn into and gently "walked" through the painting through a simple but precise placement and positioning of the shapes.

When you experiment with repeated shapes, begin by choosing your subject. Look at your subject from several different viewpoints, then determine an arbitrary number of times to repeat your shape on the page. I suggest that you create three paintings using the same shape and the same number of repetitions. This will help you to understand how the relationship among the various shapes changes with each different arrangement. For example, suppose you choose five apples as your shapes. For your first interpretation, place the five apple shapes separately on the page, so that they are isolated from one another. Placement is important here because each shape will affect the balance of the others. If you deliberately place the shapes in such a way that the balance of the rectangular page or paper is disturbed, you'll need to counterbalance this effect.

We often create problems for ourselves by our placement of the shapes in a painting. This can be true whether the shapes are trees in a landscape or geometric shapes in a nonobjective painting. One way to prevent such problems is to develop an awareness of spatial harmony and balance throughout the painting process. At every decision-making juncture, you'll constantly need to force yourself to decide how to create a gracefully balanced composition.

In the first exercise, because the shapes are isolated from each other, your first task will be to create a relationship among the shapes, then design a background that unifies the page. You can do this very simply using patterns of color, light, and shadow.

The second exercise in this series is much like the earlier exercises using your name to tie the edges of the paper together. By using shapes that are connected but not overlapping, you will create a chain that breaks the page into three basic shapes or areas.

For the third exercise, you will create a design in which five shapes overlap and become one shape on the page. In this case the apples will lose their shape identity because their individual shapes will be altered each time one overlaps another. If the apples overlap the boundaries of the page, then the textures, colors, and lines intrinsic to apples will be major design determinants.

You work with these design problems every time you paint, whether your shapes are buildings or simple rectangles. The decisions you make—how closely to view your subject, how clearly to define it, which part of it to emphasize—are decisions you make either consciously or unconsciously every time you paint. Without a clear understanding of this process, your paintings will lack conviction.

This chain of sandhill cranes creates a strong design across the page.

EXPERIMENT WITH SHAPE RELATIONSHIPS

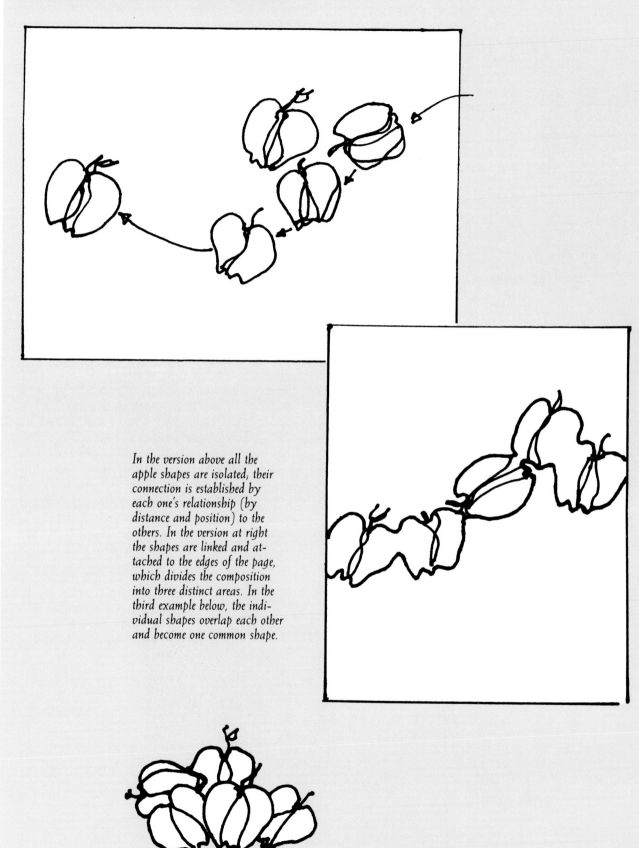

In the version above all the apple shapes are isolated; their connection is established by each one's relationship (by distance and position) to the others. In the version at right the shapes are linked and attached to the edges of the page, which divides the composition into three distinct areas. In the third example below, the individual shapes overlap each other and become one common shape.

IDENTICAL SHAPES INSPIRE DIFFERENT DESIGNS

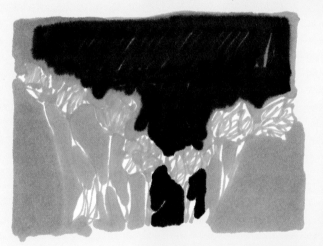

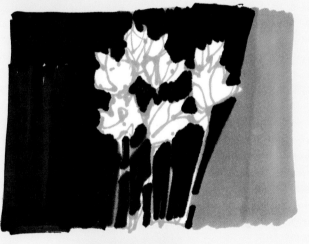

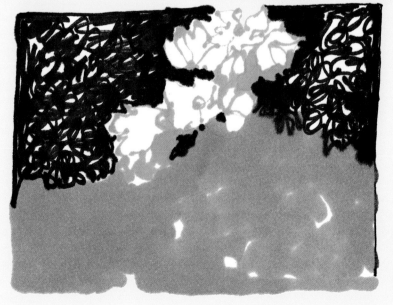

The same seven flower shapes were used in these wash drawings to produce four very different compositions.

REPEATED SHAPES

There is no right or wrong way to arrange repeated shapes. It is the relationship you create among the shapes that makes your design work.

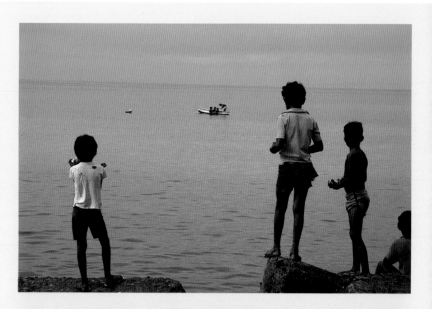

In the natural world, one shape is often repeated many times over. Artists can use this lesson from nature to help them in their own creative work.

Breaking the Surface

The picture plane is flat and two-dimensional. When we paint we are trying to break the barrier that is the surface and create the illusion of depth within its boundaries. Traditionally, the artist has used two-point perspective to create distance: the vanishing point on the horizon to which all things recede, or aerial perspective in which cooler, more muted colors and softer forms define our distance plane, suggesting a recession into infinity. However, with the advent of space travel, our ideas about space have been altered drastically. Theories of time and space are very different from the days when traditional methods of painting were established.

Today, artists are seeking a more relevant form with which to create spatial illusion while maintaining the two-dimensionality of the surface. Many contemporary artists are interested in conveying an image where time and space overlap, a suggestion of simultaneity. Paper cast in molds, or divided and layered to allow pathways into the paper surface are becoming more and more popular. Layers of colors, textures, and applied surfaces are also used to create the feeling of a series of planes overlapping in space.

An illusion of spatially overlapping planes can also be created by manipulating the perspective, focus, or scale in a painting.

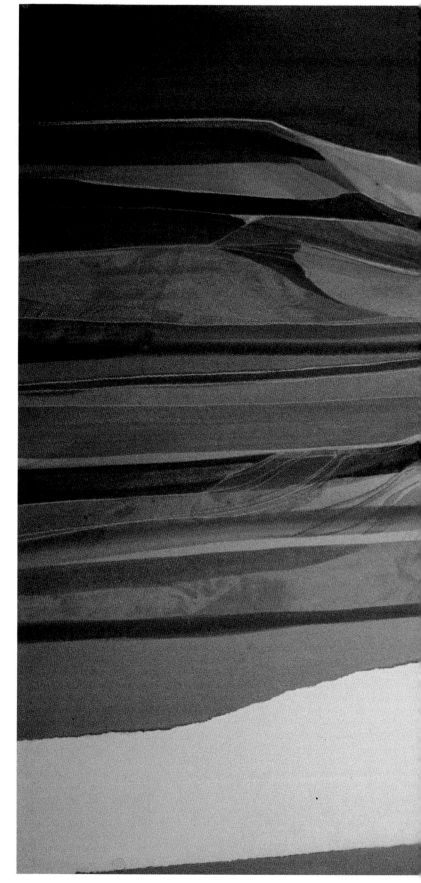

LAYERED TIME,
watercolor and acrylic
collage on 4-ply rag board,
32" × 40" (81.2 × 101.6 cm).

*The rolled-back surface
of this painting suggests
the peeling away of the
layers of space.*

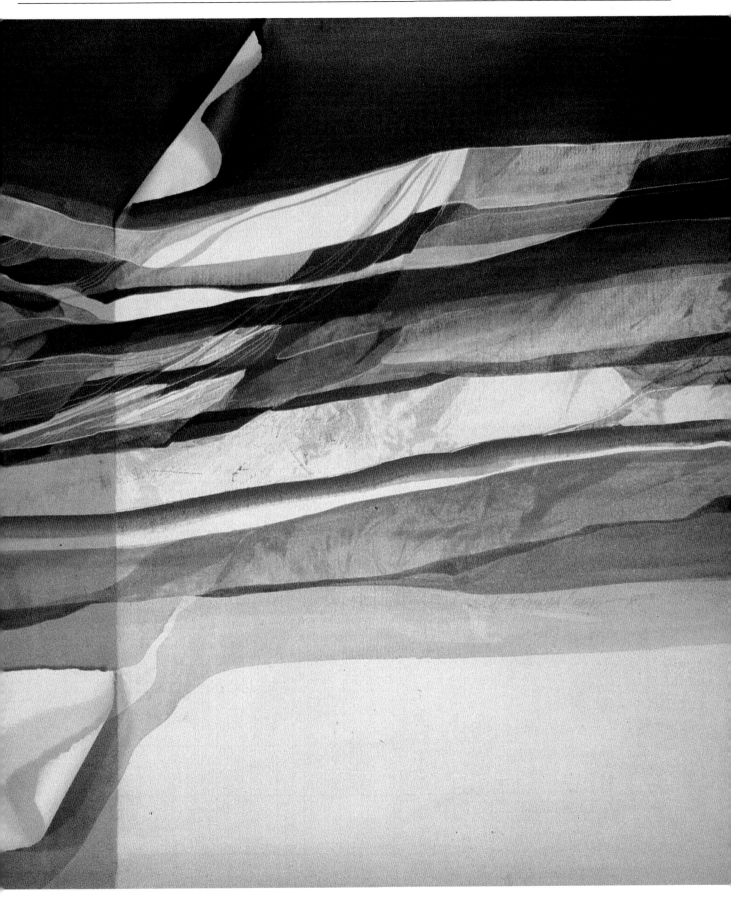

Changes in Perspective

For the following exercises think of your paper as the first of several overlapping planes, where each receding plane is also flat and two-dimensional. Allow yourself as many layers of planes as you want—receding to infinity. If you "break away" the first plane in places, you'll be able to view a distant plane behind it, or a distorted perspective plane. The effect is of a "see-through" perspective.

This kind of surface perspective break can be accomplished in a variety of ways. You can:

● Begin with a simple grid design and paint a landscape, allowing selected areas to "drop away" and show a view of a distance plane.

● Create an overlapping perspective in which one area of a painting seems to break and project forward.

● Use a grid design to create a painting where selected areas have suggested images or "displaced" images.

● Paint a landscape in which one area is "dis-placed" causing a break in the flow of the surface design.

● Design a painting using close-sequence photographs in which you change your angle of vision with each shot. Lay the photographs out on a sheet of paper in a design that creates a strong overall shape. Paint from this design. The effect is an enveloping perspective in which the viewer becomes a part of the created environment.

Note that when working with photographs, it is very effective to use a multiple photo-image taken from slightly changing views to create perspective of motion. Another creative way of using photographs for source material is to use multiple images in which some are slightly out of focus.

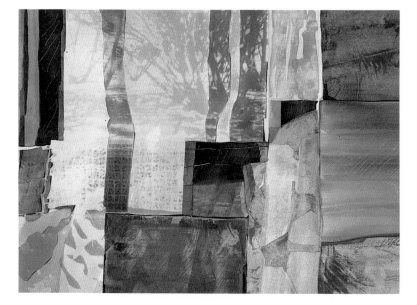

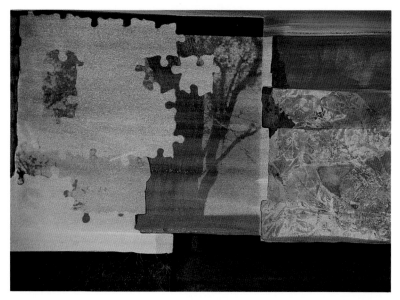

In these painting details a sense of perspective is implied by the overlapping of surface textures.

Changes of Focus

The in-focus/out-of-focus subject is a popular format today with many artists. The variations on this theme are countless. In effect this technique is reminiscent of photographs that juxtapose a highly resolved, close-up view of the subject with a background that dissolves away into a fuzzy image. In painting as well, the creative use of changing focus in selected areas can be an effective design tool.

To try this idea, design a painting using a simple grid system, but avoid the obvious dark/light patterns. Instead, each time one area touches another, make it shift from soft to hard focus. This will cause a disruption of the surface plane, creating a subtle "break."

When experimenting with this kind of painting, photographs are valuable for suggesting design patterns. You can see this potential if you take repeated photographs of your subject in different states of focus, and then lay out your design in a grid format. Use these layouts for designing a painting, then experiment with breaking the surface with patterns of infocus/out-of-focus images.

Or, you can experiment by breaking the page into curvilinear patterns to create an undulating surface. This technique creates a surface that rolls in and out of focus.

A similar effect to shifting focus can be created with the use of positive/negative forms. To explore this theme, design a grid in which the sequence changes from positive to negative subject development.

These details of painting surfaces show how artists use in-focus/out-of-focus effects and positive/negative effects to add complexity and interest to their work.

Changes in Scale

We are accustomed to using scale changes to create distance and movement in space on a painting surface. An effective way to create scale changes in a surface is to combine images that do not normally fit together, where, for example, one image is "out of context" from the others.

Photographs are again a useful tool for designing a painting that changes scale. As you observe your environment, look for out-of-scale juxtapositions. A good example is when a small object—an apple, let's say—looms over a larger object, such as a person, a house, or a car.

It is important to think about what will make the viewer stop and ask, "What am I seeing?"

Changes in Rhythm

Another way to break the surface and create interest in a painting is to change the rhythm or tempo of the design. To explore this idea, I suggest you paint what I call an interrupted sequence painting in which the subject changes abruptly making the viewer stop and question what he or she is actually seeing. For example, if my design motif was a sequence showing pairs of high-heeled shoes, but the final shoe in the sequence had no mate, the change would make you stop and notice.

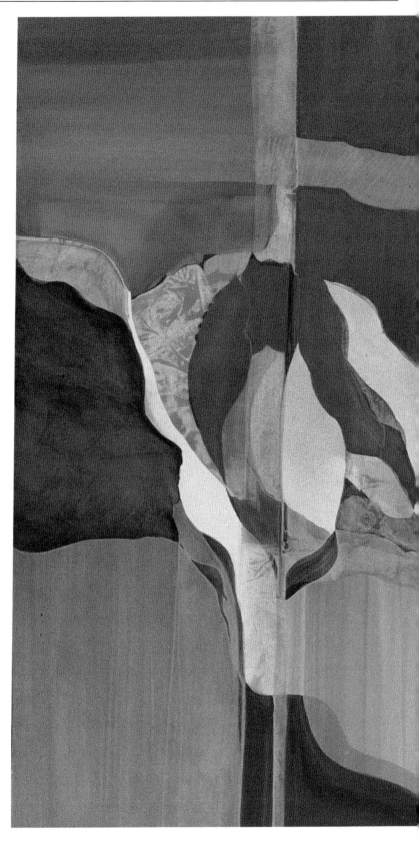

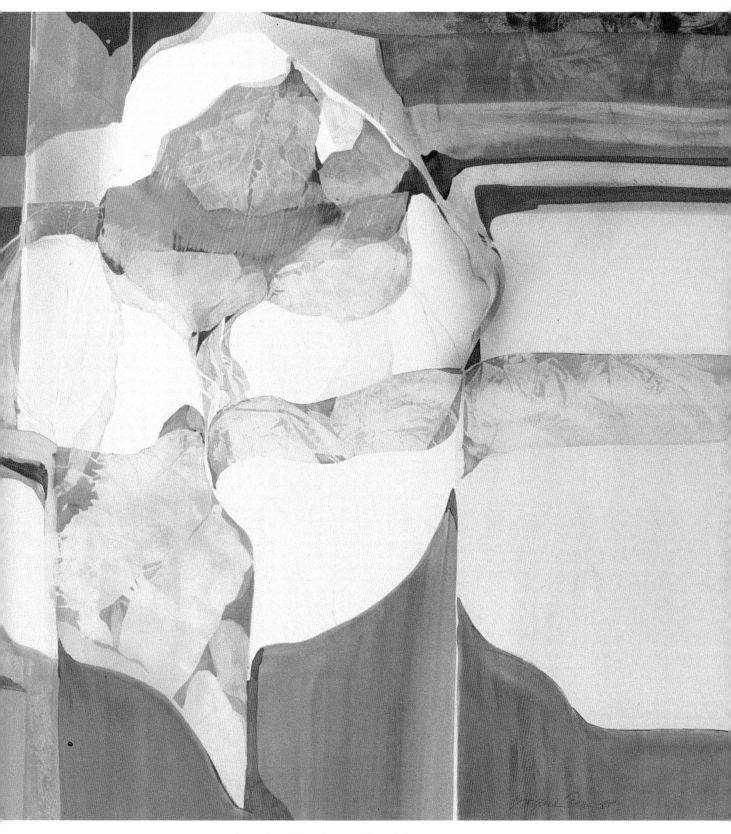

NEW LIFE, watercolor on four-ply rag board, 40″ × 60″ (101.6 × 152.4 cm).

This rather large painting was designed on a grid. Note that as the forms change and alter the scale as they move across the divisions of the grid, the surface appears to shift.

Mood as Content

The mood of a painting is established through color, value, line, texture, and form—even more than it is by subject matter. In fact, mood can be conveyed with no particular subject, or with the subject so subtly suggested that it is secondary. It is the contrasts, the rhythmic patterns, the interplay of color and value—the surface relationships—that dictate the response of the viewer to your image.

Learning to control the mood of a painting by manipulating these relationships is valuable experience for later translating a mood to a specific subject.

Often in painting we arrive at a finished work that is technically well executed but somehow "misses the point." It is not definitive of the feeling we had wished to express so it lacks meaning.

Content is the underlying meaning in art. I recently read something about the difference between "purpose in life" and "meaning in life" and while I have forgotten much of it, these two phrases linger in my mind. If you relate this idea to painting, purpose becomes the art of designing, the mechanics of producing a painting, while meaning is that part of your own inner self that you project into the painting, which is what I call content.

If I go out to the woods to paint a tree, and I predetermine that "I shall paint the woods in blue today," taking along several assorted tubes of blue, I am surely going to find a red bird sitting in my tree singing merrily. I need to be alert to all the many variables of any painting, to allow my senses to dictate. I need to listen, to feel, to sense, to let the painting suggest color and form and texture. In this way I am allowing the dynamic forces within myself to become an integral part of my art.

If you stay with your feelings a while you will know how to express what it is you would choose to express. We are often in such a hurry to speak and act. Give yourself time to allow your thoughts to linger in your mind a while.

Sometimes it is helpful to identify verbally the mood you wish to express. Then in your

MOOD PATTERNS

Agitated lines create excitement.

Flowing line creates calm.

Angular shapes and hard edges convey excitement.

Round shapes and soft edges convey calm.

Staccato intervals mean excitement.

Rhythmic intervals mean calm.

Intense colors and quick color changes say excitement.

Neutral colors and gradual changes mean calm.

Sharp value contrasts suggest excitement.

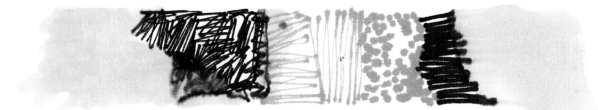

Close value relationships suggest calm.

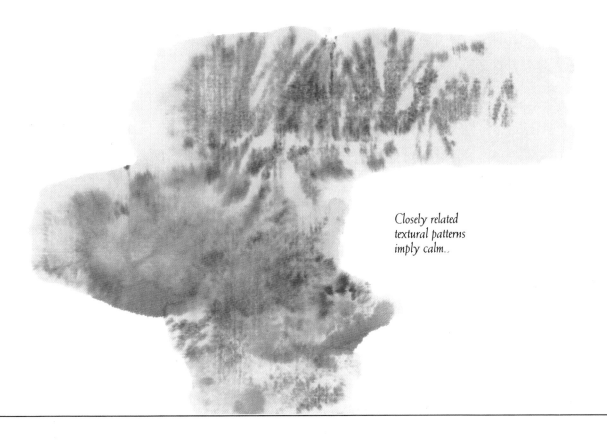

Contrasting surface textures imply excitement.

*Closely related
textural patterns
imply calm..*

sketchbook or on a scrap piece of paper make some quick gestural paintings from your "verbal sketch."

Try some quick verbal sketches. Experiment with the emotions of anger or agitation or aggression. Explore words like marching, as opposed to drifting or dancing; contemplation, meditation, solitude; or laughter as opposed to weeping.

One especially illuminating way to understand how an artist's mood affects content in art is to examine the work of other artists for those elements that suggest mood in their work.

In the same way that we work to "center" or balance a composition with our shapes or patterns, it is possible to bring the mood of a painting toward a sense of "center" by balancing the elements of color, value, line, and form.

If you establish a mood that requires quick contrasts of value, agitated line, strong and intense color, you can pull it back toward center by softening or neutralizing other areas of the paintings. However, don't neutralize the mood in your painting so much that you lose the feeling you set out to create. The temptation is to pull a painting into safer territory. You can level a painting out of existence, thereby sentencing it to a no-feeling feeling. Be careful that you don't remove the "you" from your paintings.

The placement of elements is also a factor in conveying mood. If your forms are placed high on the page or painting surface, or in such a way that the eye is directed upward in the design, the mood of the painting is lifted. If these forms are placed low or pull the eye to the lower part of the painting surface, the mood is lowered.

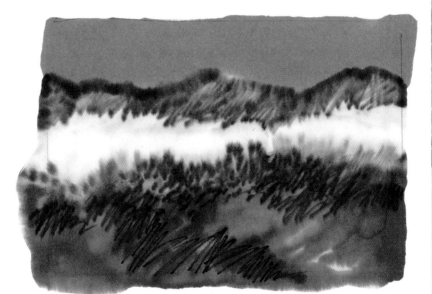

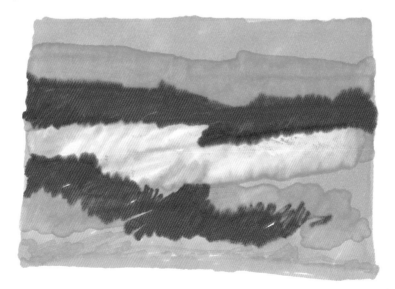

Through differences in color, texture, shape, intensity, and line patterns, two very different moods have been created in these simple landscape sketches.

ANCIENT WALLS 13, watercolor and acrylic collage, 22″ × 30″ (55.8 × 76.2 cm).

Though somber in color, the energetic tempo of the linear forms and light-dark contrast raises the mood of this painting.

Idea and Image

If your method of painting is idea oriented rather than subject oriented, the subject, or arrangement of forms, is chosen to fit the imagined idea. In working from idea to image, mood can be the impetus for the selection of forms that create your painting. Exercises in shifting mood are meant to free you to design unself-consciously. Reaching a point of intuitive use of these tools is the goal. Then it is possible to give up control and direct the flow of the painting much the way the conductor directs an orchestra. You direct the design onto the paper; you do not force it. In this way design becomes an extension of you—an expression of your own nature.

Challenge your imagination by working from an idea to an image using a concept such as a metaphor. Invent symbols that define your identity, combining interests from childhood, remembered treasures, dreams, and hopes for the future into one image. Paint this assemblage of symbolic forms as a self portrait—a personal metaphor. You will find symbols that can be carried over into other paintings in meaningful ways.

Or design a collage in which you use fabrics that are suggestive of your self-imagined image. Choose prints and colors that "feel" like the self you see yourself to be, flamboyant patterns that are your most undisciplined self, and quiet patterns suggestive of you at your most calm. Integrate the two sides

THE SOOTH SAYER,
watercolor on paper,
12″ × 20″ (30.4 × 50.8 cm).

This painting is filled with symbols meaningful only to me. The design, with its "see-through" area in the center, invites the viewer in.

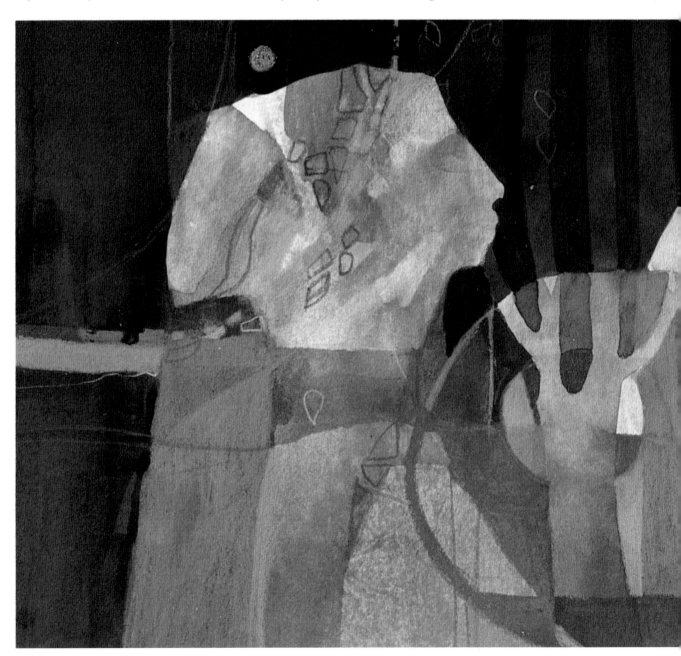

of your nature with painted forms taken from the fabrics, enlarging or reducing the design forms and weaving a painted design.

Life—and consequently art—is filled with paradoxes. We are faced with contradictory and puzzling situations every day. If art is indeed expressive, it's an excellent form for sorting through and analyzing our reactions to these situations that confront us and sometimes confuse us.

To experiment with this idea, create illogical combinations of forms that you feel would make good subjects for painting. Then establish relationships among these unlikely components. This is a good exercise for developing relationships of elements in your painting.

Exercises of this sort can be the spring-

board to a creative series of works. But more importantly they can open doors to new ways of perceiving art and life. It is easy to get caught in the drama of fine art—art for history's sake—and lose sight of art for the sake of creating. In truth we are very much present in our time, and it is wise to portray the world as we live and experience it. Let history concern itself with who among us will be remembered. If we busy ourselves worrying about posterity and fail to participate in the now of art, we are missing a chance to use our most effective form of expression to explore our thoughts and ideas about the world in which we live.

The Role of Humor

So much of what takes place in our lives is humorous to the point of bizarre. Artists who point out the humorous (the bizarre) through their art act as society's conscience. Often they precipitate an environment for social change. However, it is not necessary to be a satirist to indulge your sense of fun in art.

Because painting demands intense concentration, it is sometimes a relief to allow yourself a more whimsical viewpoint. In my workshop classes, we often paint our subjects out-of-context to provide that relief. This always requires a fresh look at the form itself, and encourages the artists to be more relaxed.

Consider, for example, the fish fossil that has been the subject-form for many of my paintings. One day I could not resist putting the fish "safely in a tree." This became my visual reference to the epigraph by Alan Watt's in the front of this book.

When painting with humor, you can engage your wit and paint your subject in an environment where it would not be ordinarily found. It is one more way to surprise the viewer—to involve him or her in the process of art.

Surprise the Viewer

Employing the element of surprise in painting does not mean I am suggesting that you use gimmicky methods to draw attention to your work (although I will admit that a number of artists have become famous that way). I am suggesting that you draw your observer into a dialogue and appeal to the inquisitive nature we all have by allowing viewer interpretation to complete the work. One way to achieve this type of participation is to teach yourself

to leave areas of the page suggested, and undefined. The image is then necessarily completed by the viewer.

Recently, during a workshop discussion, a participant mentioned the term "unobtrusive measure" which she defined as the quality that makes people look at some paintings longer than others. Such paintings have their glass cleaned more often, the floor in front of them swept more often; they simply seem to possess some silent force, or "unobtrusive measure," that commands attention.

Of course, artists hope that people will linger over their paintings. We don't want them to be able to cast one quick glance and walk on.

One way to understand what makes one painting work and another not is to play the part of the observer and ask yourself: "Does this painting make me want to stop and look at it a while? Does it invite me to smile or to question in some way what I am seeing? Does it suggest a mood that evokes a response? Does it have some element that surprises my eye, an unexpected touch of color, marks I can't quickly define, a shape that seems misplaced?"

Often it is the unexpected that gives a painting that quality of being special. Sometimes it is simply that a painting has not conformed to a preconceived standard.

Breaking the Rules Successfully

One of the best ways I know to firmly grasp the rules of design and learn to use them to advantage is to break them deliberately.

When you begin a painting by breaking an arbitrary rule, you force yourself to design creatively. To prove this, try a series of exercises where you break a rule you have considered an absolute in the past. Your own inbuilt sense of design will help you resolve the problem you have set for yourself. Trust in your intuitive sense of design to lead you to create a balanced composition. When you feel the need for a certain element in a certain area, chances are that is exactly what the painting needs. With practice it becomes easier to assess what is needed to solve the problem.

Each of the following design suggestions embrace a design taboo. See how well you can break the rules in these exercises. To begin, design a page that is divided through the center. Then invent creative ways to coun-

teract the static quality of such a design.

● Place your subject-form in the center of the page and consider ways you can draw the eye to one side or the other of the page by shifting the subject's weight slightly. Make the subject-form such a dynamic presence that it works in a centered position.

● Place wedge-shaped pieces at the edge of a page and experiment with shapes that will balance this rather awkward form.

● Compose a painting that has no strong value contrasts to count on. Use a value range of two through seven. Then explore other kinds of surface contrasts that will make the composition work. One way is to use color changes and let the values remain static. Another way is to allow value and color to stay very close but let the surface textures vary to create contrast and change.

● Design a painting that has no real focal point; the eye is moved about the page rapidly by active contrasts of value and color.

● Restricting yourself to only using the form of the circle, design a painting by inventing ways you can move the eye easily into and across the circular form.

As you complete these exercises, remember not to take them too seriously. The only possible loss to be suffered here is a sheet of paper. Don't allow your mind to be occupied with what you will do with the finished product; just experience the process. Risk being truly creative in your work. The knowledge gained is worth far more than that to you.

Taking Risks in Art

Our educational system has done a good job of teaching us not to make mistakes. From the time we are small, we are taught to practice what has really already been accomplished, not to risk seeking new avenues for fear we might be "wrong" and suffer the humiliation of failure. This form of learning is good for building a foundation for new knowledge, but it does not encourage venturing into the unknown areas where new knowledge is waiting to be discovered. It takes an adventurous nature to seek new answers, to be inventive, to create—in short, to be an artist.

NESTING 4, watercolor on rag board, 32″ × 40″ (81.2 × 101.6 cm).

A circle, centered on a page, spirals out to become a fluid form.

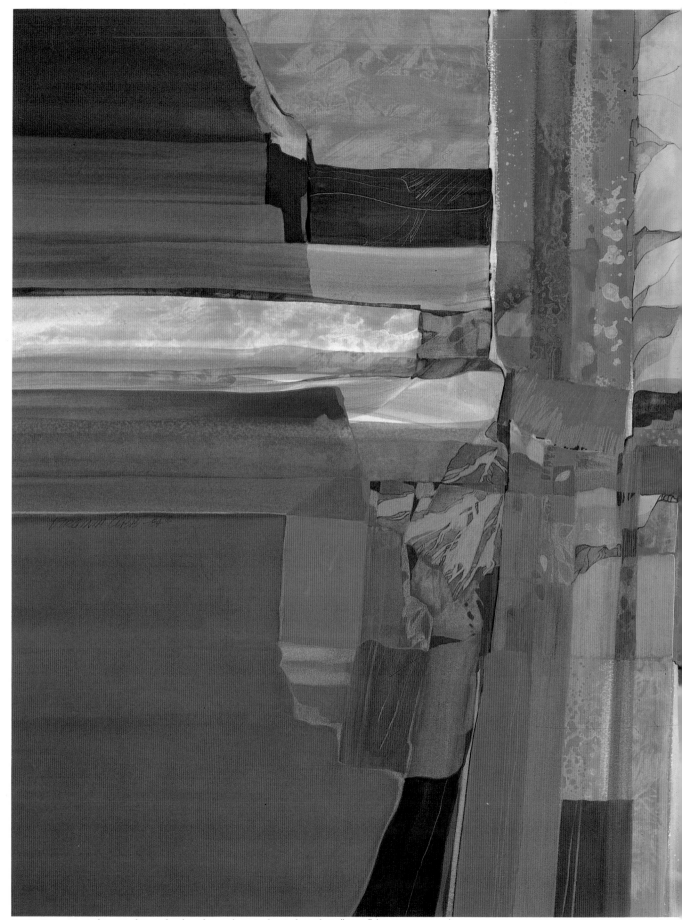

JOURNEYS, watercolor, acrylic, and colored pencil on 4-ply rag board, 34″ × 34″ (86.3 × 86.3 cm).

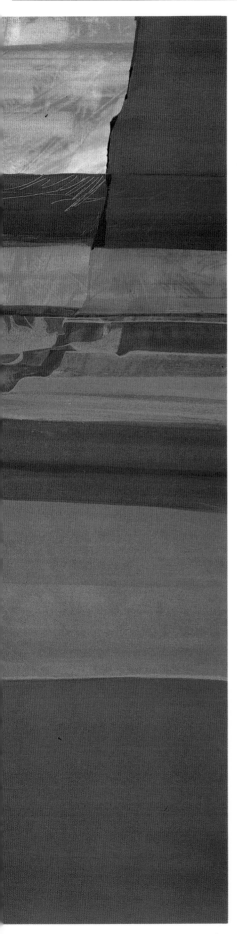

Part Three

ENRICHING THE PAINTING SURFACE

*"It is only when we let ourselves be open
to experience . . . to being surprised,
that we can experience anything new,
anything that we have not decided on in advance.
It is only in this way that we can change.
If I decide in advance what the experience
should be, I cannot have a fresh experience."*

—From *Einstein's Space and Van Gogh's Sky*

Experimental Painting—What Is It?

Experimental painting is not a style of painting or a school of art—it is an attitude. I use the term to describe a flexible method of painting that allows for the introduction of new techniques. It is a working method that does not separate the realist from the abstractionist; it encourages creative growth and change. Experimental painting simply means working inventively with your tools, trying anything you can think of to bring some new excitement into your work. But, more importantly, it means experimenting with ideas and concepts, challenging the established rules, questioning any arbitrary sense of what is appropriate in painting. It means refusing to settle for the repetitious.

Experimental painting requires a willingness to take risks, because there are no guarantees. The feeling that each effort must result in a so-called successful painting can have a paralyzing effect on an artist. It is important to allow an experimental piece to flow and to work with what is happening on the paper, rather than force a painting to conform to a predetermined plan.

Working experimentally will also help you to develop an awareness of the process of art, an involvement with the act of creating. To create does not mean to reproduce; it means to produce anew. However, experimental painting is not an excuse for sloppy, gimmicky results where a little of this and a little of that are thrown onto the paper, allowing the paint to make all the decisions. It is possible to control and refine an experimental piece to the same degree of finish that you would have in a preplanned painting. New techniques must be refined to become tools you can work with confidently. Otherwise you will achieve spotty results at best.

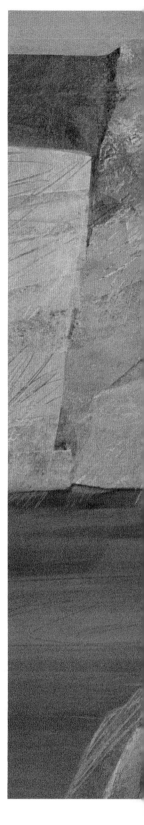

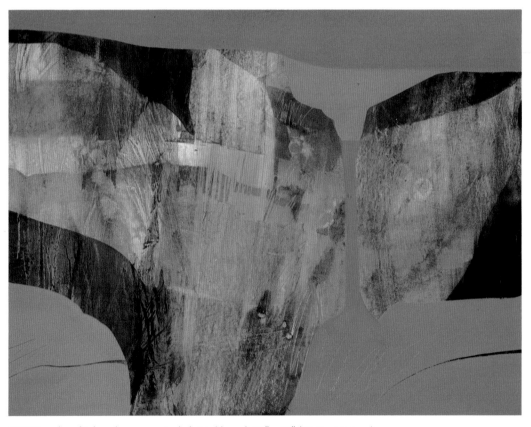

MATRIX, **colored ink and gesso on 4-ply bristol board, 22″ x 30″ (55.8 x 76.2 cm).**

This painting was a demonstration piece in which I used a variety of applied textures as an example of layered opaque and transparent colors. After the surface was completely textured, flat opaque color was laid in to define shapes and create a dynamic design. The brilliance of the flat color gives an additional contrast.

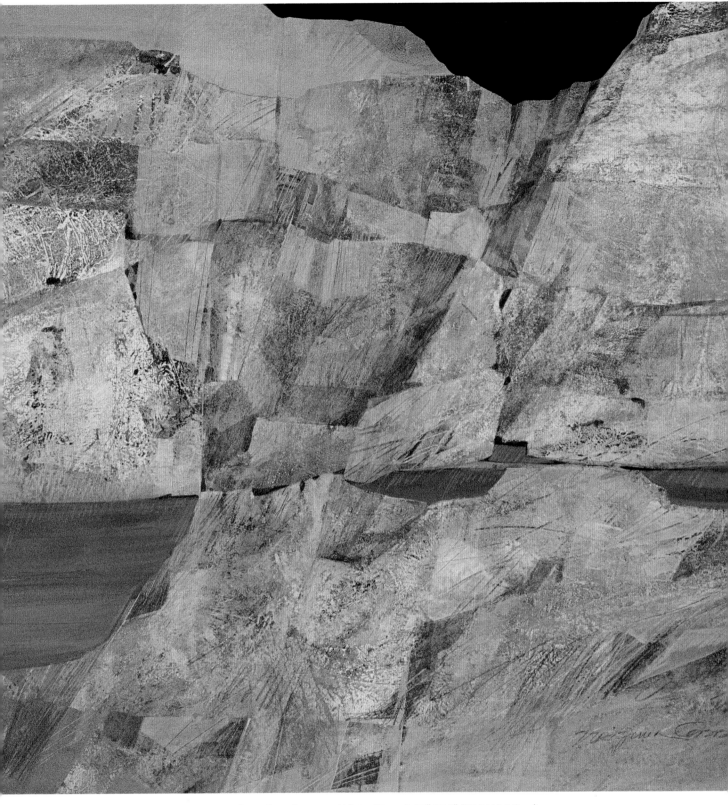

QUARRY, watercolor and acrylic on 4-ply bristol board, 30″ × 38″ (76.2 × 96.5 cm).

The surface of this painting was built up in alternating layers of India ink texture and color washes. A strong opaque was then overpainted to define the overall form of the granite wall.

Understanding Materials

I have a few materials that I consider necessary, but mostly I work with any tools that I can find. I collect art materials and have a weakness for new and untried tools. Consequently, I have a studio full of brushes, trowels, brayers, as well as various other tools, much of which I could manage quite nicely without. Typically though, I usually return fairly quickly to my favorites, which I regard as old and well-worn friends.

Brushes. A good quality two-inch flat brush is a necessity in my work, it is often the only brush I use on a painting. I sometimes work with other flats, graduating down to the quarter-inch size. Perhaps I could have included photographs of these rather stubby and well-worn brushes, but it would serve no purpose. The tools an artist uses are so personal, a brush becomes a familiar and comfortable tool only when I have broken it.

When you select your brushes, try them out first in your hand to see if their weight and balance "feel" right to you. Ask the salesperson for a bowl of water so you can try the edge or point for flexibility. Sometimes a beautiful looking brush does not have the bounce that a less aesthetic and often less expensive brush might have. Choose tools that suit your personal needs.

I think it is wise, especially for the less experienced painter, to use large brushes. Learn to use the chiseled end of your brush to draw, and the side to drag color onto a page. Turn your brush in your hand as you paint so your brush marks will have a fluid quality.

Don't expect your brush to do it all for you; watch your hand and wrist follow the motion of the line you are trying to create, and feel the rhythm all the way through your arm. The way we hold and turn our brush is as important as the grip a tennis player or golfer uses to make a stroke.

I know artists who paint with valuable and well-cared-for red sables, and artists who paint with stubby brushes that are as abused as mine. The magic is not in the brush; it is in your hand. The magic is the communication between you and the brush and the paint, and it comes with patience and practice.

Trowels, brayers, and scrapers are also useful tools for applying paint. Anything that will pick up paint and move it from one place to another is worth a try. Hardware stores are wonderful places to find new tools.

Paint. Color permanency is a primary concern when selecting paints. Although there are many beautiful colors, especially among the inks and liquid watercolors, many are so fugitive that they will fade within days. Even though all paint manufacturers have permanency charts, my only gauge for colorfastness is testing. Color testing is easy. Simply wash a wide swatch of color across your paper and let it dry. Then cover a strip of the dry color with masking tape and lay the paper in direct sunlight. After a week or two, check for color permanence by comparing the masked area (protected from the effects of sunlight) with the unmasked area.

Paper. Paper is vital to the watermedia painter; and the only way to gain an understanding of what each different paper surface offers is to try out as many different kinds of paper as you possibly can.

For my own work, I find a smooth, hard-surface paper best for textural effects. The smoother surface allows full control of details and textured patterns.

For direct painting there are many excellent medium- and rough-grained papers. And the variety of handmade paper and exotic imported paper is unlimited.

When experimenting with new techniques and trying new materials, it's not necessary to use expensive high-quality paper. In fact, it's a good idea to have a large supply of inexpensive paper on hand for trying out new techniques and new ideas.

Developing the Surface

The minute you put a mark on paper you have broken the two-dimensional surface. In Part Two you experimented with breaking the surface by changing perspective, scale, focus, and rhythm. In this part of the book, you will explore ways of creating surface variations that break the surface plane.

The most underemphasized element in watercolor is the underpainting. The structure that lies beneath your final washes is the skeleton of your painting, whether it is transparent watercolor washes, built-up textures, or collage elements. To use watercolor merely

SMOOTH

MEDIUM

ROUGH

as surface decoration is to stop short of the beautiful depths of color and texture that can be achieved with layering techniques.

With knowledgeable use of the water media medium, it is possible to create vibrant surfaces that give more dimension to your work. The examples shown in this section emphasize methods of developing richer surfaces by creating a strong understructure for your paintings.

This part of the book is divided into five sections:

Layering Color on Color

In this section you will practice the ways of building watercolor in layers to create a surface rich in color depth. By alternating opaque and transparent watercolor, your paintings will achieve an increased vibrancy.

Layering Texture on Color

Here you will learn about methods to enrich the painting surface by adding opaque water media (gouache, acrylic, and tempera) to transparent watercolor. The increased density of the paint allows new possibilities for texture development.

Building an Undertexture

Building an undertexture is perhaps one of the best ways to add character and depth to your paintings. The undertexturing methods described in this section include charcoal and dry color washes, printing techniques using inks and fabric, and colored pencil.

Collage Techniques

Specific materials (handmade papers, fabric scraps, printed papers) and techniques for building up a collage surface are illustrated and discussed.

Constructing a Layered Surface

In this section you will learn to build a multileveled surface for three-dimensional effects. The benefit of working with actual relief forms is that they help you to visually break through the frontal plane of the two-dimensional painting surface.

Different surfaces will create different textural effects. Try working with smooth, medium, and rough grain papers to familiarize yourself with the effects of each texture.

Layering Color on Color

Watercolor's greatest appeal lies in its translucence and in its spontaneous, fresh quality that allows for quick interpretive painting. But watercolor is far more than that. Its deep, rich color that can be achieved by contrasting flat color with translucent color gives the watercolor medium a vibrancy that cannot be matched by any other painting medium.

Watercolor is a most flexible medium. It can be understated or overstated. It has been called a sketcher's medium and accused of nonpermanence, yet ancient scrolls painted in water paints have survived intact through the centuries without the chipping and cracking that is evident in oil paintings from the same period.

Those of us who paint in watercolor have a lifelong love affair with the medium, which, because of its very nature, has a seductive quality, drawing you into the process of creating while you watch it take place. I have always had the feeling that if I am there to provide the color, watercolor will paint itself. Yet the paintings that seem most simple, with flowing and intermingling shapes blending and overlapping, are often the paintings that require the most control and the most understanding of the hows and whens of watercolor.

The complaints I hear most often from students in a workshop are of muddy color or of darks that are not as rich and vibrant as mine. The brights, the clears, the clean and beautiful transparencies of the first layer are easy. I suspect that is why watercolors are so often left at that stage. But you shortchange yourself if you do not learn the next few steps. The rest of it is simply a matter of understanding your colors and the timing of the medium.

To take full advantage of the color-dimension possible in watercolor, I build my color in layers, alternating transparents and opaques to achieve the richest surface quality.

If you think you do not like opaque color, I challenge you to reexamine your palette. Do you work with cerulean blue? Any of the cobalt colors? Cadmium red or yellow? How about the earth colors—yellow ochre, raw sienna? These are opaque colors.

Try separating the truly transparents from the opaques and painting for a while using only transparent colors. I would venture to guess you will quickly tire of the results and long for some of that gutsy quality the opaques add to your palette.

In my own palette I keep mostly opaque colors, squeezing out the transparents on a tray each day when I begin painting so they will be fresh and clean. When I open my palette for a classroom demonstration, the reaction is usually one of surprise. The participants are incredulous that my rather dull-looking assortment of colors is what I use to achieve some of the brilliant colors they found in my paintings. "You mean you paint those glorious colors with that palette?" they ask. The implication is that my palette is full of muddy color. My answer is that the "glorious" colors are only glorious in relation to something. If every color you use is brilliant, there is no contrasting area of opaque color to set off the high-key areas. Too much glorious color is simply boring.

Let's examine what happens when you contrast some of the opaque and transparent colors and then build up a layered surface. By tinting areas of the painting with a strong dye color, such as alizarin crimson or phthalo blue or green, you will establish a "color feel" that will influence succeeding layers. You can add a sense of color vibration to the surface by laying in a wash with opaque color and then blotting it. For even more textural variety, water can be used as a wash and then blotted, just as if it were paint. The paint-blotted and the water-blotted areas will make an interesting textural juxtaposition. Each succeeding layer will add a new richness if the layers contrast opaque to transparent, or warm to cool.

DOUBLE FLOWER, watercolor on 4-ply rag board, 46″ × 32″ (116.8 × 81.2 cm).

This painting was built up with alternating layers of warm and cool color. The original underlayers were warm transparent yellow gold. When laying in the first washes for this kind of painting, I reserve the whites, which are much larger at this stage than they will be when the painting is finished. This allows me to close in on the whites to modify them as needed.

Successive washes were laid in, first cool, then warm. The resulting surface has a vibrant feeling of warm/cool tensions.

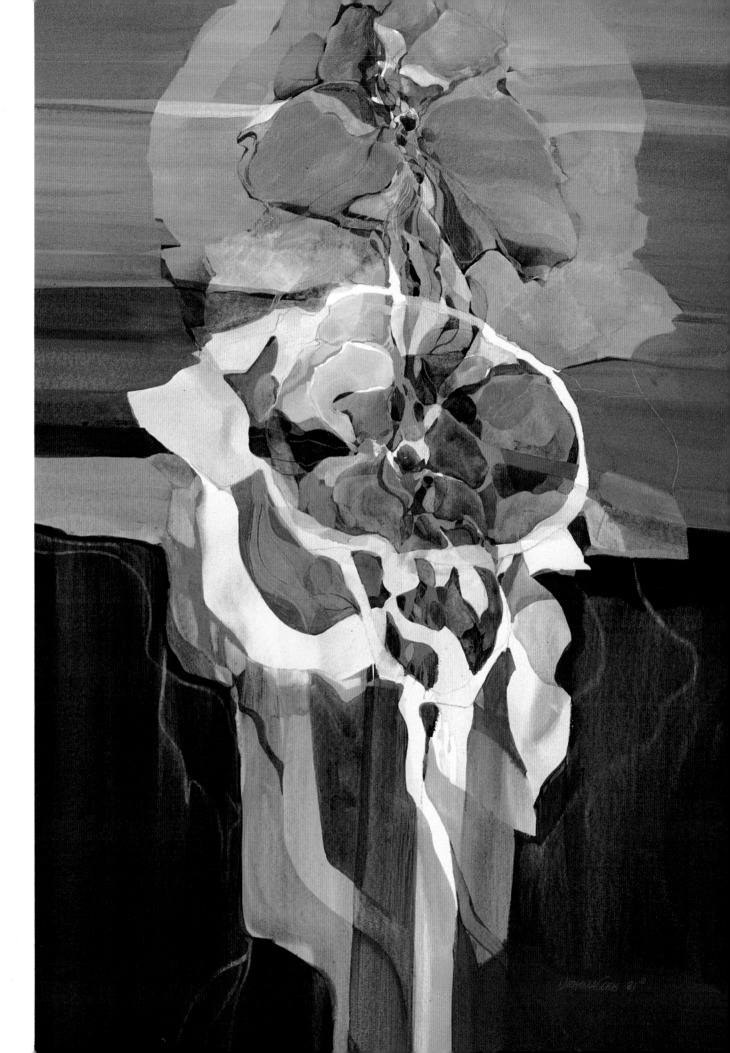

CONTROLLED EFFECTS

Layers of cool-toned subtle color create a richly textured painting surface.

Successive layers of reds and yellows produced this soft blending of warm color.

When a streak of bright transparent dye color is juxtaposed with flat opaque color, it becomes all the more brilliant.

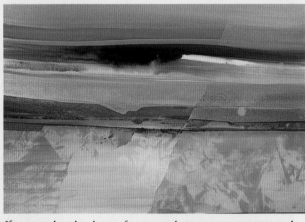

If you wash a thin layer of opaque color over a transparent, and then blot the area, the transparent color will shine through.

When alcohol is splashed over wet color, it adheres to the top layer of color and allows the undercolors to assert themselves.

When alcohol is dropped into wet paint, it creates an additional textural effect.

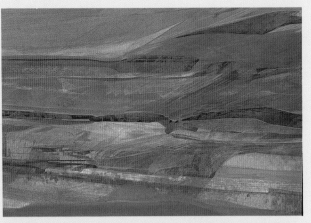

The opaque gray areas in this landscape detail help to establish the rhythmic, shadowy forms suggestive of mists gathering over distant hills.

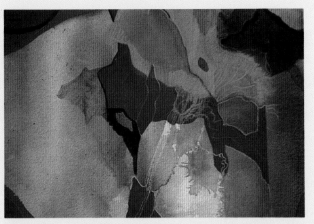

When keyed against thick opaque color, the soft transparent underwashes of this flower form take on a luminescent quality.

By using plastic wrap, or some other malleable material, you are able to lift out color from an area and print the lift-off in an adjoining area.

A veil of cool opaque color, thinned and scraped back, allows subtle variations of color and texture to form on the painting surface.

As seen in this detail, an area in a painting characterized by fragmented color and forms can be unified with a subsequent covering wash of pale opaque color.

A painting surface begins to take on a rich patina as alternating layers of transparent and cool color are applied.

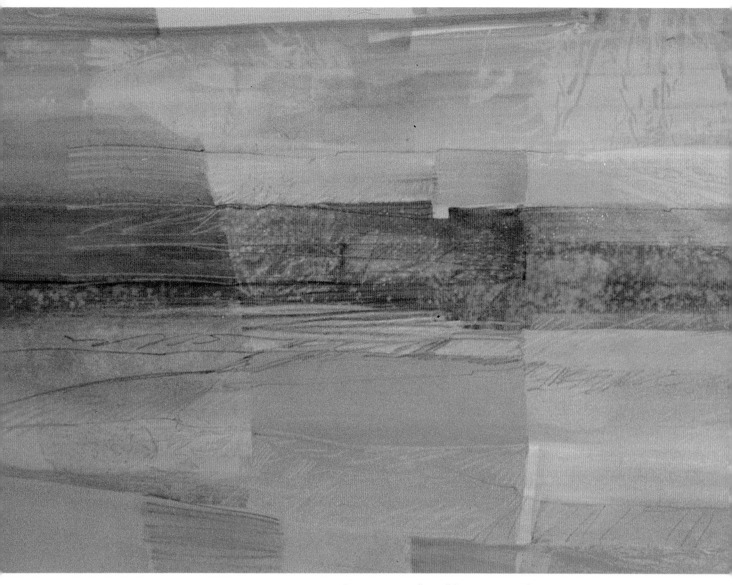

CANYON DE CHELLY 4, watercolor on paper, 14″ × 22″ (35.5 × 55.8 cm)

The value relationships in this watercolor are very close. The design depends on contrasts of warm/cool texture created by the layering of alternating transparent/opaque color.

Alternating Opaque and Transparent Color

When you alternate layers of opaque and transparent paint, you get a sense of color depth, and a surface that is rich and vibrant. By quickly blotting with a tissue or by spraying with a fine mist of clear water, you will allow for more of the underlying colors to show through. Each succeeding layer of color adds a new richness if the layers alternate opaque to transparent, or warm to cool.

To test this technique, lay out some papers with different kinds of surfaces to see how color reacts to a change in surface texture. Then wash random passages of brilliant transparent color onto the various papers. For the first few tries, use a warm under-color such as a new gamboge washed in freely over large areas of the paper. The next few layers should be color related to the new gamboge, such as a yellow ochre or a darker warm opaque like Indian red. Blot the new layer quickly to see what a nice transition you can achieve with a transparent warm and an opaque warm. Wash back over part of that area with another layer of warm transparent, perhaps a slightly warm-toned color like alizarin crimson.

In the end, though, the colors you use make little difference; the important part of the process is reaching an understanding of which colors are opaque and which transparent and how each affects the paper and the other colors. This is something that can only be learned with practice and some adventurous color mixing.

Liquid Dyes and Inks

Liquid watercolor dyes and colored inks were originally intended for commercial use by graphic designers and illustrators, but these brilliant, concentrated colors also appealed to fine artists. The only problem was that many of these dyes were not permanent, or color-fast. Most manufacturers, however, have rated their colors for color fastness, so check the labels or charts for degree of permanency. To be certain that a color is truly permanent, I suggest you test it for yourself by exposing a color to direct sunlight for a week or two. For warm undertones, I especially like to work with Luma brand's crimson, permanent orange, and acorn brown colors; and for cool undertones, I like permanent green and blue. By mixing up a wash from one or more of these brilliant dyes together with a sedimentary tube color (making a thick pasty consistency), I can blot an area back to a brilliant and strongly patterned textural area. The dye color will sink into the paper; the sedimentary color will lift out. In this way I can achieve rich and lively color areas.

For a highly textured, more variegated look, you can treat your paper ahead of time by applying drops of rubbing alcohol to specific areas of the paper. Begin by washing or splashing on drops of alcohol first, allowing it to dry. Then paint over the alcohol-stained surface with a brilliant dye mixture. While this color is still wet, apply alcohol to some areas and watch how it affects the colors. Color over alcohol will darken a surface, but alcohol applied to wet color will lighten the surface.

Gouache Effects

To thicken my watercolor washes, I occasionally will add gouache. This technique helps to give some of the final washes some added conviction. The areas of built-up, opaque color create a more three-dimensional feeling to the surface.

Metallic gouaches are especially effective for giving extra life to the painting surface. I seldom use these full strength, as I prefer to mix them with watercolor to temper the shine. The resulting areas have a spark that watercolor alone does not have.

The addition of a metallic color to a dark or near black color is especially effective because a more or less flat black can be infused with surface lights.

Layering Texture on Color

Once you have established a strong color base, made up of built-up layers of color on color, you will then be able to go on to develop beautiful areas of high-relief texture on top of that base.

Mixing watercolor with other water-based media is an effective technique for creating a more tactile and more painterly painting surface. When you add acrylic medium to a transparent watercolor, you are essentially making the mixture into an acrylic paint, which gives you all the attributes of the acrylic medium—fast drying, denser paint

quality—combined with the brilliant colors and fluidity of watercolor.

If you add gesso to transparent watercolor, you are transforming a transparent color into an opaque one, which will give you yet another variation in color.

By layering metallic and luminescent inks, acrylics, and gouache colors over transparent watercolors, you can add a vibrancy to the painting surface that you never felt possible.

Layering pencil over watercolor washes is also an effective way to build up a textured surface.

GEODE,
watercolor and gesso
on 4-ply rag board,
32″ × 40″
(81.2 × 101.6 cm).

Thinking of the circular nature of the geode, and the contrasting dark outer surfaces and crystalline inner surfaces, I built this painting up from a warm, light underbase to darks and back to light again. The result is a surface that remains two-dimensionally flat and yet gives the illusion of depth.

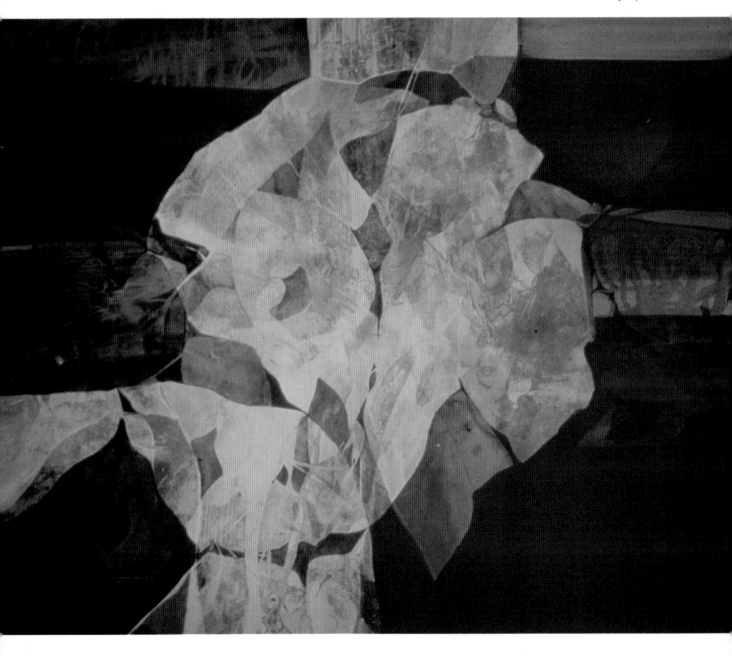

CONTROLLED EFFECTS

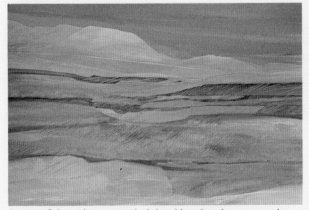

Layers of thinned gesso, applied then blotted with paper towel, produce a subtly textured surface.

These whites were printed by lifting color from my palette with plastic wrap and then carefully transferring it to the paper.

Colored pencil scumbled over a thick, wet layer of white has the effect of bringing disparate parts of the painting surface together.

When colored pencil is laid in over a large area of the painting surface, it has a unifying effect.

A layer of warm-toned gesso brushed over a strong blue creates color vibration.

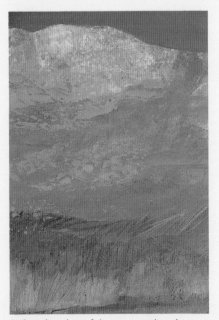

When the white of the paper is played against areas of white paint, an interesting textural effect results.

Building an Undertexture

The most underemphasized element in water-color technique is the underpainting. The structure that lies under your final washes is the skeleton of your painting, whether it is transparent washes, built-up textures, or collage elements. To use watercolor solely as a surface medium is to stop short of the beautiful depths of color that can be achieved with layering techniques.

Although we normally think of an underpainting as washes of color, there are many ways of developing an underpainting. For example a textural substructure makes an excellent base for color. Such an undertexture can be made from inks, charcoal and dry colors, colored pencil, and opaque media. The resulting painting has a character that could not possibly be achieved by painting in color first and adding texture later.

When working with color layers, a watercolor paper with some tooth, or texture, adds a dimensional quality to the painting surface. However, the grain of the paper gives you a predetermined effect; it necessarily dictates the character of the resulting texture. In my work, I prefer to use a smooth, hard-surfaced board (known as hot-pressed paper) for my undertextures. In that way, I can better control the developing textural patterns.

LIFE CYCLES 3,
**watercolor and dry charcoal
on 4-ply rag board,
32″ × 40 ″ (81.2 × 101.6 cm).**

The dramatic undertextures in this painting were achieved with a single wash of charcoal powder, before the color washes were applied.

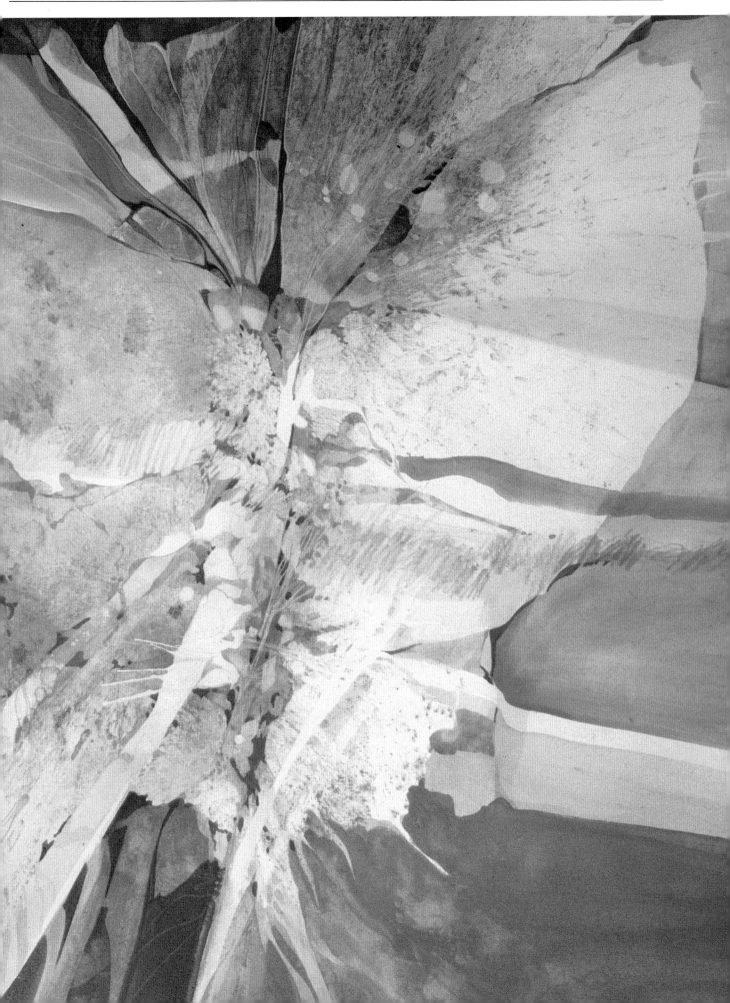

When you want to suggest a specific texture, begin by
sketching in the basic lines and patterns of your form.
Then as you pour, experiment with different angles
and different heights, or even different rhythms. In the
charcoal design at top right, the water was poured
from overhead, creating an explosive design effect. At
bottom right, the water was poured diagonally over the
paper. The result is more flowing and organic than the
overhead pour.

Charcoal and Dry Color Washes

Charcoal wash is a particularly interesting techique because it is a spontaneous medium that can also be used to design dramatic underpaintings. There are many ways of working with these washes, and I will demonstrate a few in this section, but in order to truly understand the diverse potential of this medium, I suggest you try as many ways to apply washes as you can think of.

When I work with powdered washes, I prefer to work outdoors for two reasons. First, it gives me a chance to work outside in the fresh air, and second, and more particularly, pouring these washes is necessarily messy. Note: it is possible to work with this medium under more controlled circumstances; that option is covered later on page 100.

To begin, scatter some charcoal over various types of paper surfaces. Each paper will offer a unique texture. Then pour clear water over the paper; each direction of the pour will affect the result. For example, if the container of water is held high and poured quickly, an explosive looking design will result. If the water is poured slowly in short bursts, the effect will be flowerlike patterns of texture. Either way, some very beautiful textures can be achieved this way.

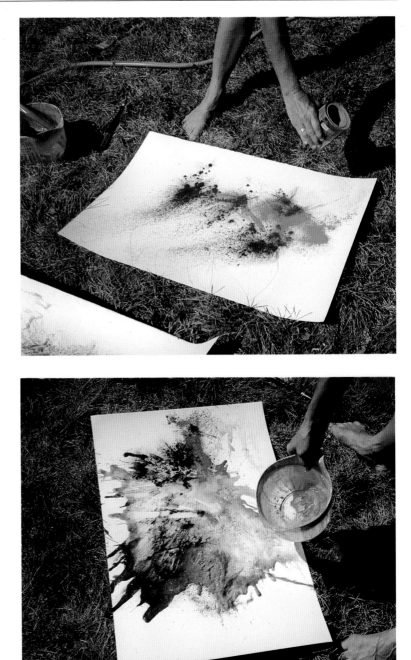

This technique consists of two parts: First, you scatter the dry charcoal powder in a controlled but random fashion over the paper (top). Then, once you've achieved the colors you want and the desired amount of pigment, you pour clear water washes over your design (bottom). The results can be startlingly suggestive of organic forms as well as very beautiful.

This photograph of a quarry inspired the interpretation at right. To preserve the whites of the sunlit areas in the sketch, I quickly brushed in clear water with a long, flat brush. The water creates a resist effect, which allows me more control over the placement of the highly textured areas. While the resist areas are still damp, I sprinkle on the powder and then pour water across the paper to wash it off. As you can see in the photograph, the textures are more evident in the shadow areas. The charcoal-washed areas are very descriptive of the shadows on the rock face of the quarry wall. Once the charcoal had dried, I developed the drawing further by erasing out the lights and adding line work to define the patterns of the stone wall.

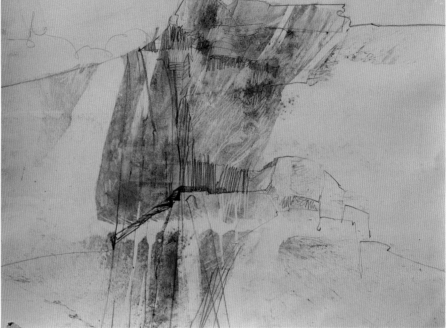

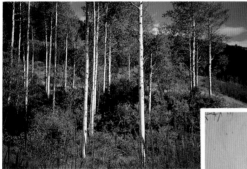

Using this photograph of an aspen grove as a guideline, I brushed in treelike forms with a narrow, flat brush. Yellow ochre and turquoise powders in combination with charcoal powder were used for the preliminary washes. By using the colors with charcoal, I was able to create the feeling of a deeply shadowed wood. Note that in the watercolor sketch a few strategically placed diagonals help to break the monotony of the vertical lines.

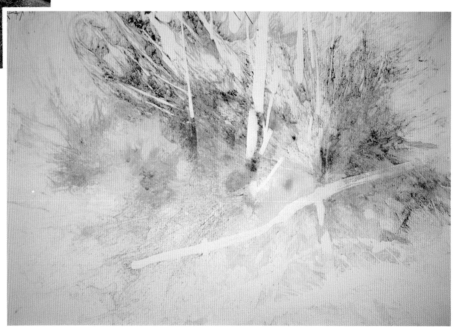

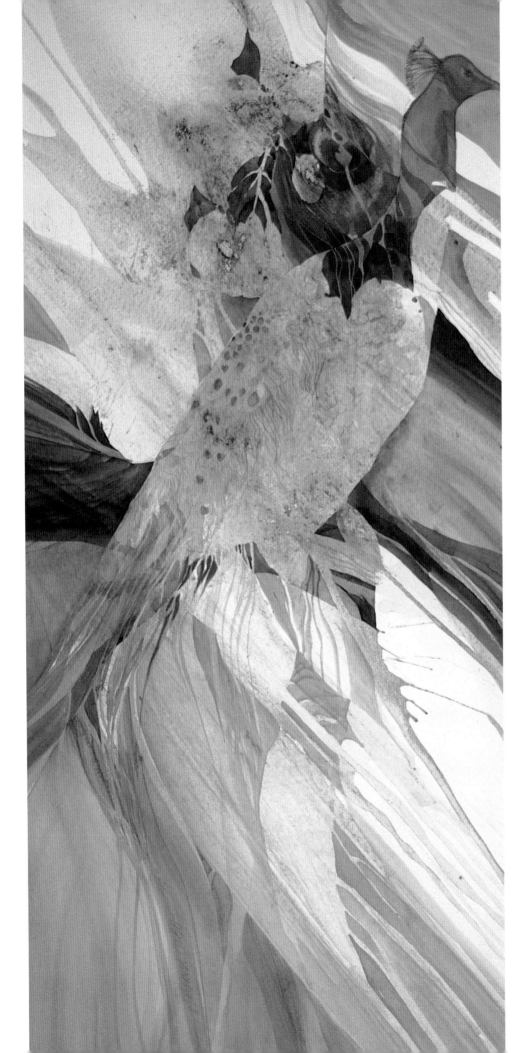

Because the colors and patterns of feathers are among the most beautiful in the natural world, I especially like to incorporate their designs into my paintings. In this watercolor sketch, I used a directional pour to develop the rhythmic patterns I saw in feather textures.

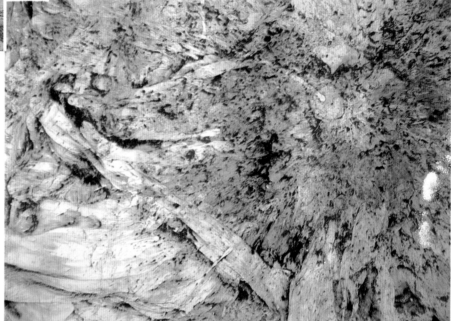

These undertextures, created with poured charcoal washes, serve as the underpaintings for the washes of color that structure the painting surface and define the shapes. With practice, you can learn to control the patterns and create descriptive textures such as stone, weathered wood, rust, and beach debris.

STONE TEXTURES

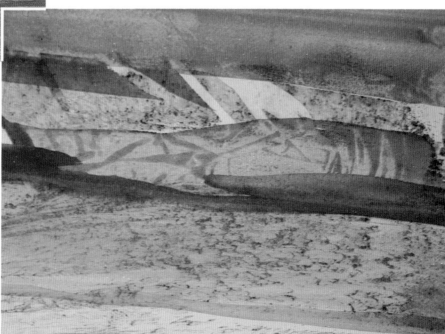

WEATHERED WOOD TEXTURES

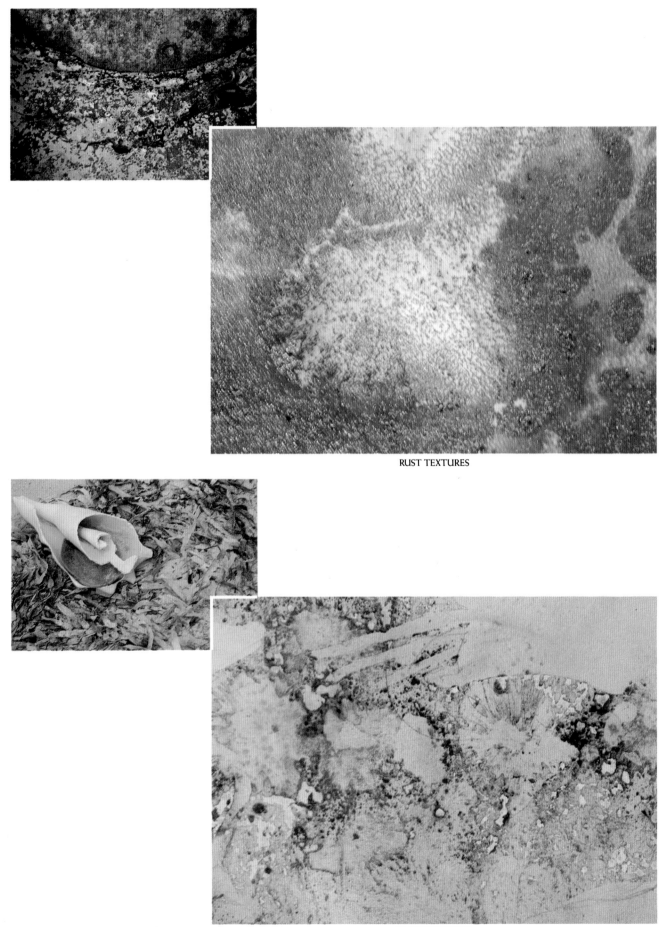

RUST TEXTURES

BEACH TEXTURES

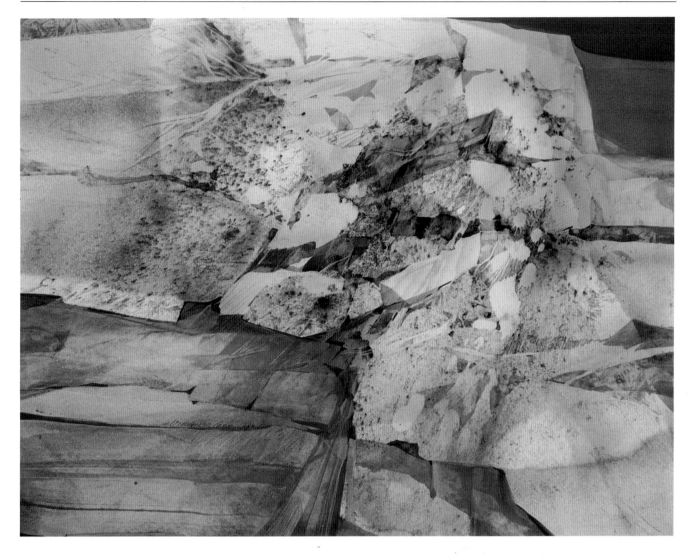

Using successive washes of powder, it's possible to create a multilayered textural effect. Here I washed in a random layer of charcoal, first blocking out some rock forms with clear water. Once the initial wash was dry, colored powders were sprinkled over the paper and then washed off, leaving a second layer of texture and color.

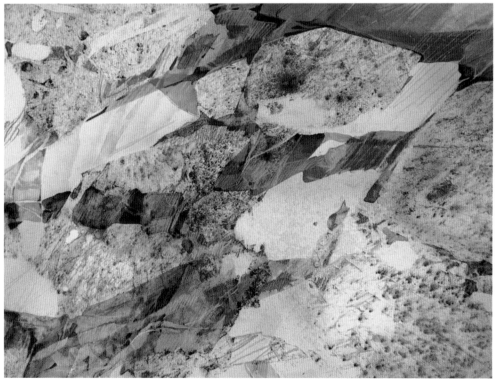

Once the paper was completely dry, branchlike forms were created by lifting out areas with a fine-pointed eraser. Very limited color washes were used to simplify the textural areas as well as to unify the whole.

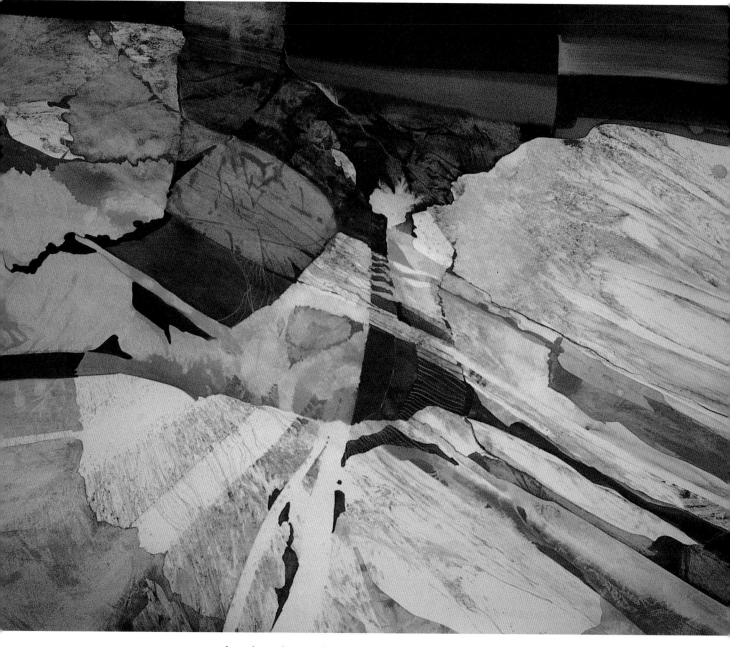

ENERGY FLOW, dry color and watercolor on paper, 22" × 30" (55.8 × 76.2 cm).

In this painting the dynamic flow of the textural wash dictated the pattern of the light/ dark design.

Adding Watercolor Washes

Color development can be added once you have textured your paper and are satisfied with the effects you've created. It's a good idea to spray the surface with a workable fixative before adding the color washes. This will fix the powdered texture to the paper so that it won't lift out and smudge the subsequent layers of color.

I like to construct my paintings with a build-up of simple washes and allow the texture to show through. In the early stages of a painting, try to think of textural washes in the same way that you think of color washes. By choosing the most successful areas for emphasis, and covering over the less effective passages, it's possible to create a strong design.

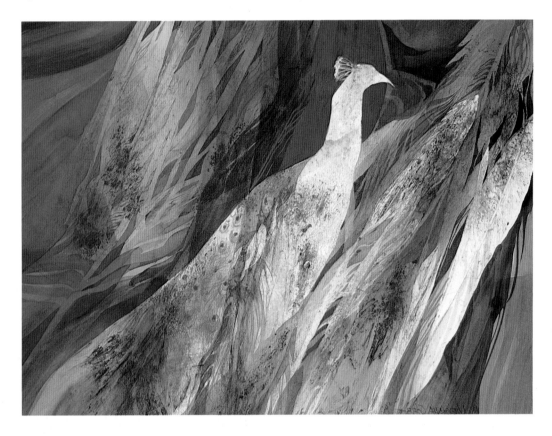

Here, I used a clear water wash for the area of the bird's head because I wanted its silhouette to contrast with the abstract feather patterns. Subsequent color washes were used in enlarged patterns to repeat the feather textures and create a diagonal flow to the overall design.

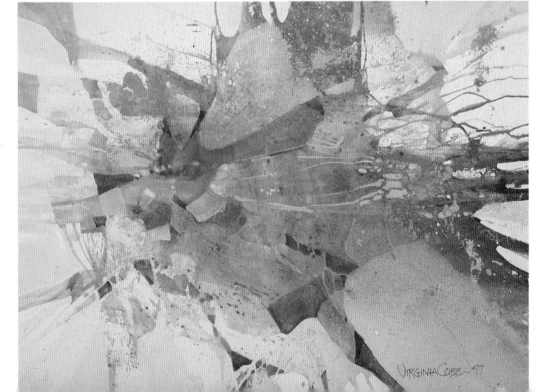

To create the textural dynamic in this abstract design, unplanned washes of colored powders were followed by poured clear water washes. Subsequent contrasting watercolor washes were added later to divide the space and to emphasize the energetic spirit of the design.

A charcoal wash was used initially to describe the fossilized textures of the fish form (left). Successive washes of built-up color and texture were added to create the patterned background (below).

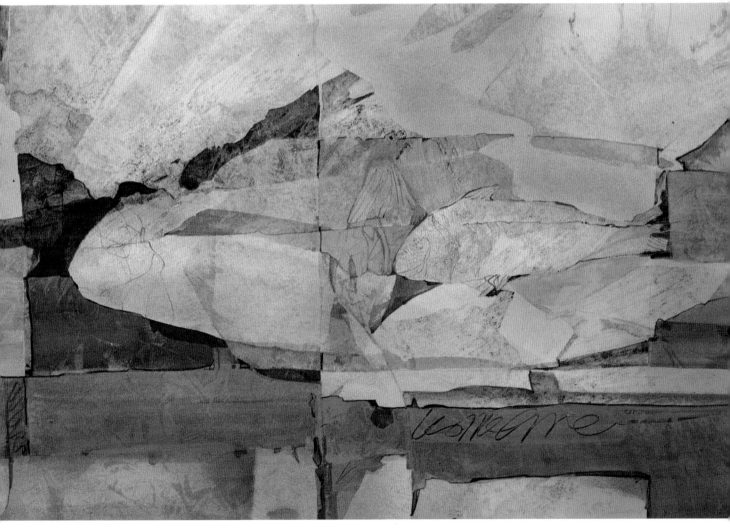

ADDING COLOR

When working in the studio with powdered washes, I confine the texture to limited areas of the page. Because this is to be an indoor pour, I need a large plastic trash barrel (50 gallon capacity) lined with a plastic bag. All my pours are then placed over the trash barrel so that I can control any spillage.

After drawing in the dove form, I carefully painted around it with clear water. A large circle around the dove was also defined with clear water. Powder was sprinkled only onto the circular form near the center of the paper and a small amount of water was guided into that area. The puddle of water was gently manipulated by rolling the paper from side to side. As soon as I was pleased with the design forms within the textured areas, I lifted the paper by its edges and poured the excess water off into the trash barrel.

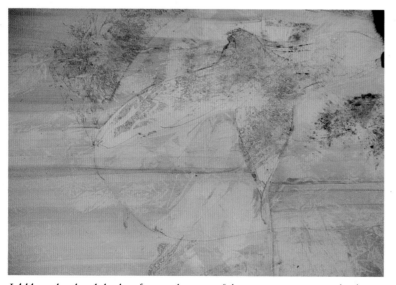

I deliberately placed the dove form in the center of the composition, at once dividing and integrating the painting surface. To emphasize the spatial division, color was floated into the four areas.

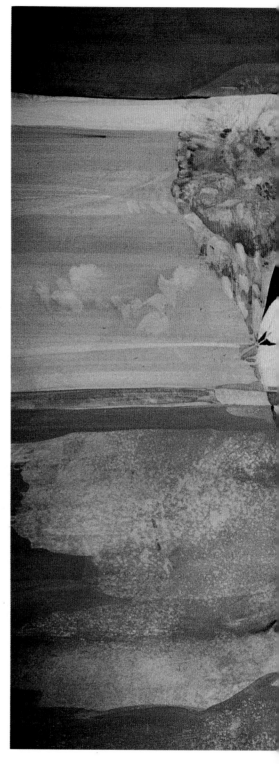

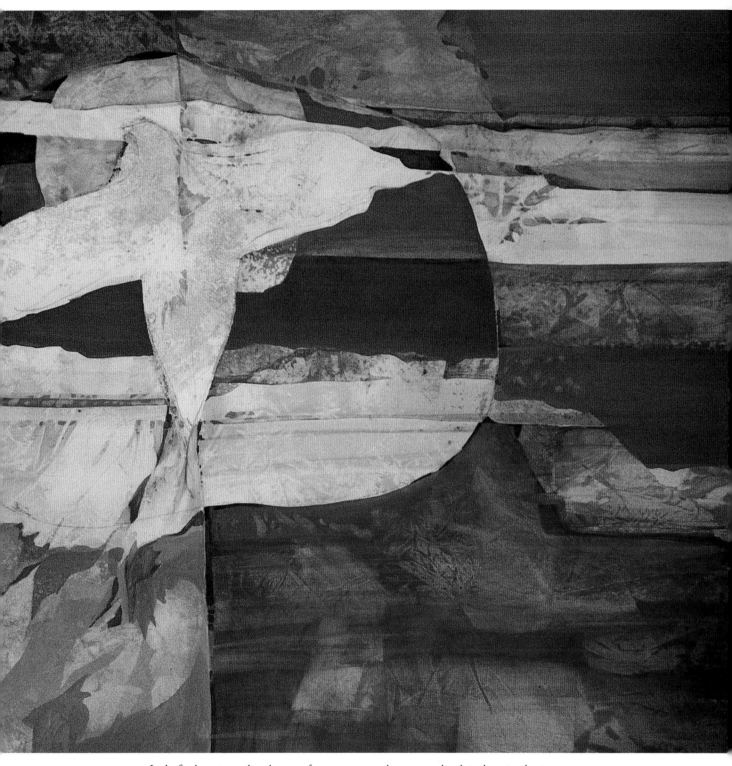

In the final version, color alternates from warm to cool to create a break in the painted surface. By lifting out color that is based on the patterns of the textured charcoal washes, I was able to tie together the overall design. Note that the background pattern has been created with layers of overlapping washes.

ADDING DYE COLOR WASHES

Inspired by this beautiful photograph of foam and colored stones on the beach, I decided to see how close I could come to this kind of effect.

Small puddles of clear water were brushed in to establish the transparent, reflective shapes of the foam. Liquid dye colors were dropped into the wet spots, staining the paper in those areas.

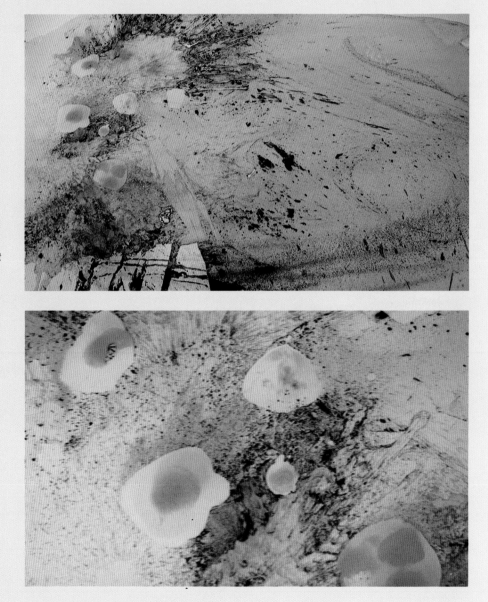

Charcoal and sienna powders were sprinkled over the paper and then washed off, leaving texture only in those areas that were kept dry. The bubblelike areas remain free of texture.

This painting surface comes close to the image I had envisioned when I looked at the photograph. At this stage it can easily be transformed into a painting of beach and sea foam.

USING A FRISKET

By cutting a frisket, it's possible to have clearly defined masked areas and to add as many layers of powder as you might wish. In this example, I used both the inside and the outside contour of a simple leaf cutout for a positive/negative effect.

Using two powders—green and charcoal—I created the first layer of texture.

Here, the paper was allowed to dry thoroughly and the frisket was removed.

A second frisket mask was put in place with cut-out shapes overlapping textured and untextured areas.

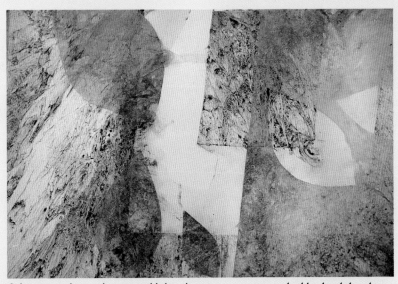

Subsequent color washes were added to the painting to create a highly detailed and complex surface.

ISOLATING A SUBJECT FORM

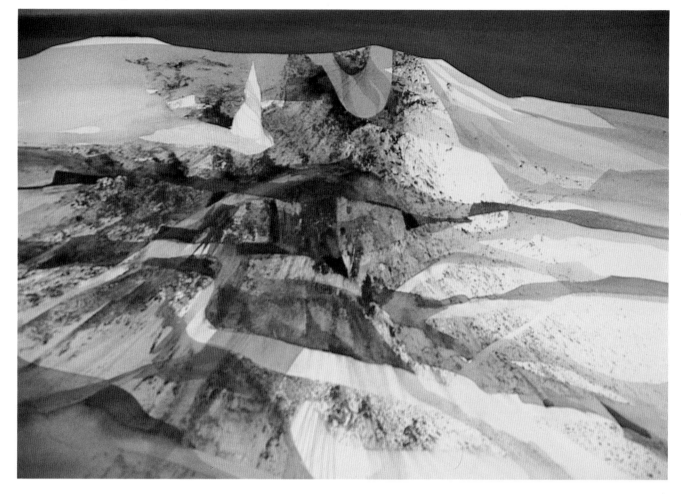

LA PALOMA,
dry color and acrylic
on 4-ply rag board,
32″ × 40″ (81.2 × 101.6 cm).

*The bird form in this painting
was brushed in first with
clear water. Other rhythmic
white forms were also estab-
lished before the color and
texture were laid in.*

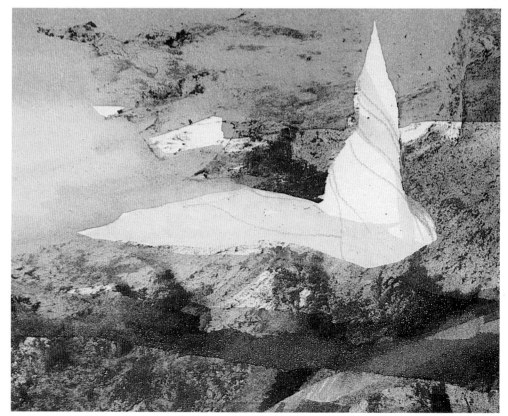

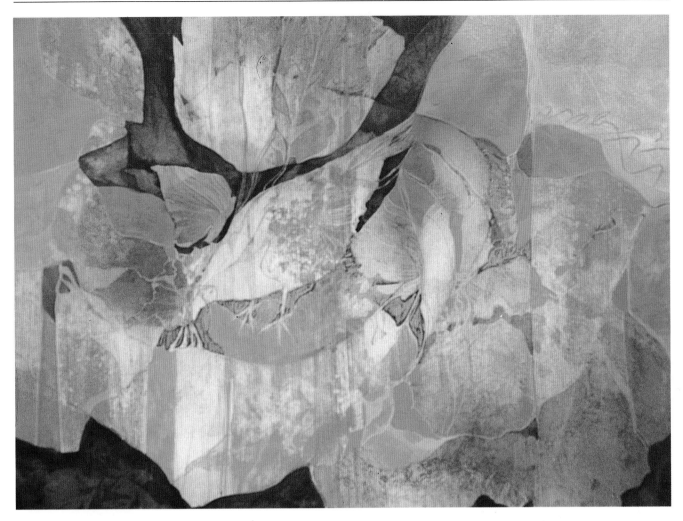

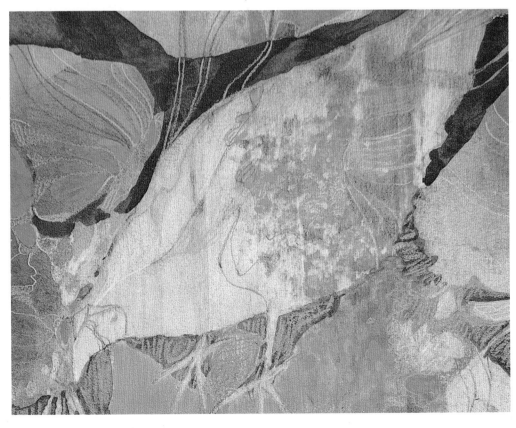

PIGEON AND BUTTERFLY,
charcoal, watercolor, and
colored pencil on bristol board.
14″ × 17″ (35.5 × 43.1 cm).

The technique used for establishing a subject form here is the reverse of that of the painting opposite. Here, the undertexture was established first with a random wash. Then the bird form was developed from the textural patterns and defined with color.

In this closeup, the bird form has been established by closing in on the textural areas with color. By allowing the textures to weave in and out of the subject form, the result is a defined shape that is separate yet integrated.

LETTING THE UNDERTEXTURE SUGGEST THE SUBJECT

Often, in the development of an undertexture, I am steered toward an image that I did not start out with. This particular piece started out as a controlled wash in the studio, in which I had used coffee for the wash-off. The coffee tinted the paper, creating a warm color in the textured areas.

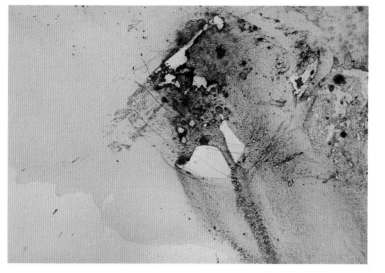

Once the paper had dried, I thought the form that emerged was so birdlike that I decided to base the painting on this idea.

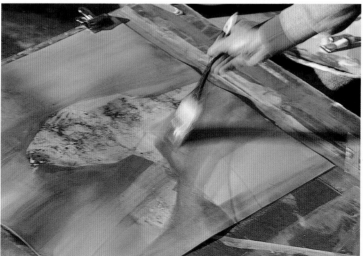

So as not to disturb the textural areas, I brushed in the color washes with a light, quick motion.

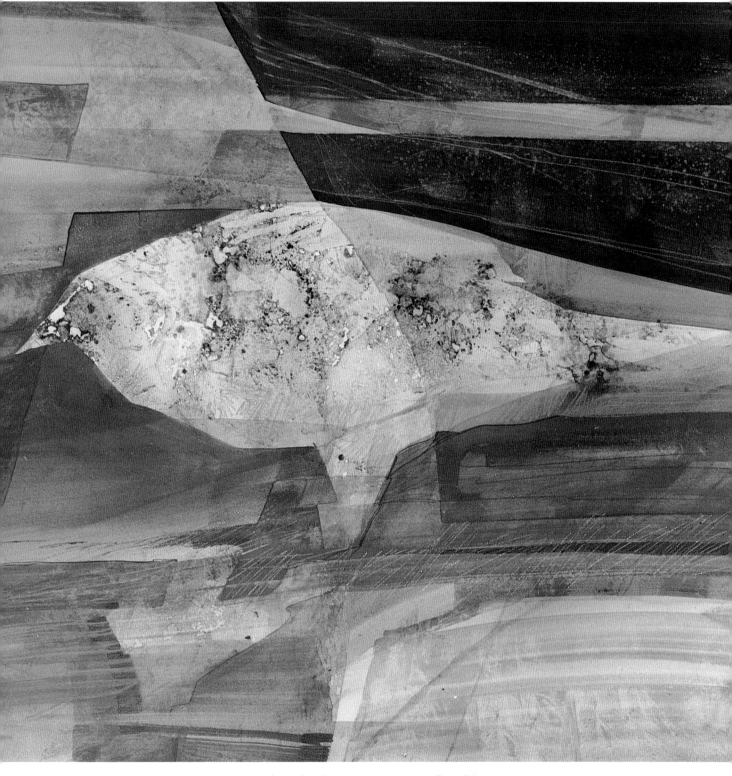

THE WEIGHT WATCHER, charcoal and watercolor on paper, 22″ × 30″ (55.8 × 76.2 cm).

I like paintings that make me smile—and this one does. The bird, rather awkward in its streamlined surroundings, has a whimsical quality.

Undertexturing with Inks

In much the same way that charcoal is used as an undertexture, inks can also be applied for a textural base. Black permanent ink can be used for a dark and dramatic base; color inks can be used in the same manner to create a color undertexture.

Using ink for textural effects is a technique I discovered by accident. I had been working on a painting that seemed to get prettier by the moment. It had so many lovely areas that I was almost too scared to work on it, for fear that I might ruin something. Yet despite these strong areas, the overall effect was weak and uninteresting. Finally, in complete frustration, I scrubbed some India ink over a large area of the paper, blocking out some of the more pleasing areas, but creating a problem that demanded I resolve it. As I worked myself out of that corner, I found that India ink underlayers were particularly effective for adding strength and drama to a painting.

Before you attempt to incorporate inks into a painting's undertexture, I suggest you experiment on a variety of surfaces first, with no finished design in mind. A smooth, heavyweight board is effective for this kind of texturing. My personal favorite for this type of work is a vellum-finish bristol board.

To begin, mix your ink with an acrylic medium to a thick, creamy consistency. There are many ways of applying the ink to the paper, with a brush, trowel, or any number of tools. What you are after really is a way to apply a thick application of ink. Then, while the ink is wet, lay a piece of plastic wrap over your surface and lift out texture by pressing a trowel or rolling a brayer over it. Next, quickly lay the plastic wrap down on an adjoining area and print the lifted texture with the brayer. The effect is of a double print, with positive and negative textures moving from dark to light.

You can use the same technique with a sheet of aluminum foil. The texture results from the aluminum foil is entirely different from that made by the plastic. Tissue paper towels, even fabric can be used in the same way to achieve a variety of textural effects.

Alternating Light and Dark Textures. By alternating areas of texture—dark on light, light on dark—the surface can be built up into multilayered patterns. Experiment with this idea by applying ink onto a piece of plastic wrap, then use the plastic to print onto a white area. To achieve the opposite effect—light on dark—paint thick gesso onto the plastic wrap and print onto the inked area.

If you want a spatter effect that is quite different from the printed textures, try applying your ink base thickly with a trowel, spraying it with clear water, and scraping away areas of the wetted ink. The wetted areas will lift out if you scrape them with a razor blade or other sharp, flat-sided tool.

By adding one of the acrylic interference colors to the ink instead of acrylic medium, you give a luminous quality to the inked dark areas. The interference colors are designed to pearlize the surface of a color without altering its color identity.

Adding Opaque Color. After you have experimented with texturing some surfaces, try washing some brilliant color into selected areas. If you use a transparent dye color, you can color an area and still see through to the textured areas underneath. If you add gesso to your color, you can create a transition to opaque color areas by blocking out some textured areas with thickly applied paint. By blotting the opaque color while it is still wet, you can "reclaim" some of the undertexture and add another dimension to the painting surface.

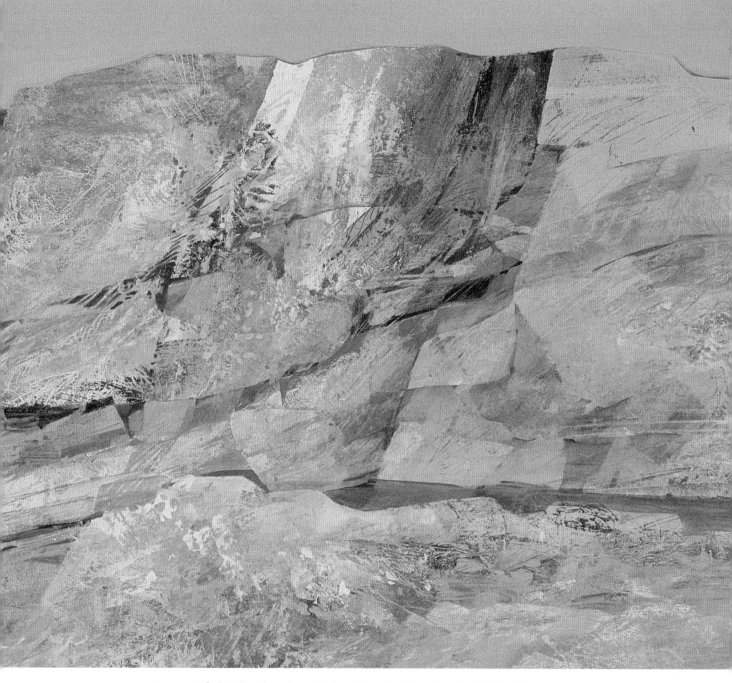

QUARRY 1, India ink and acrylic on 4-ply rag board, 32″ × 40″ (81.2 × 101.6 cm).

This painting, based on the image of a Maine quarry, was laid out first with a black textured underbase of India ink which had been mixed with acrylic to increase its density. The black underbase alters and neutralizes all subsequent color that is washed in over it. Because of the ink's dramatic effect, I purposely let it show through in certain areas.

PRINTING WITH PLASTIC WRAP AND INK

Press a piece of plastic wrap against a flat surface.

Apply the ink with a brayer (roller) or a large brush.

Turn the plastic face down on the painting surface and firmly press a brayer to the clean side of the plastic wrap.

When you lift the plastic, the crinkled surface of the plastic wrap will be imprinted.

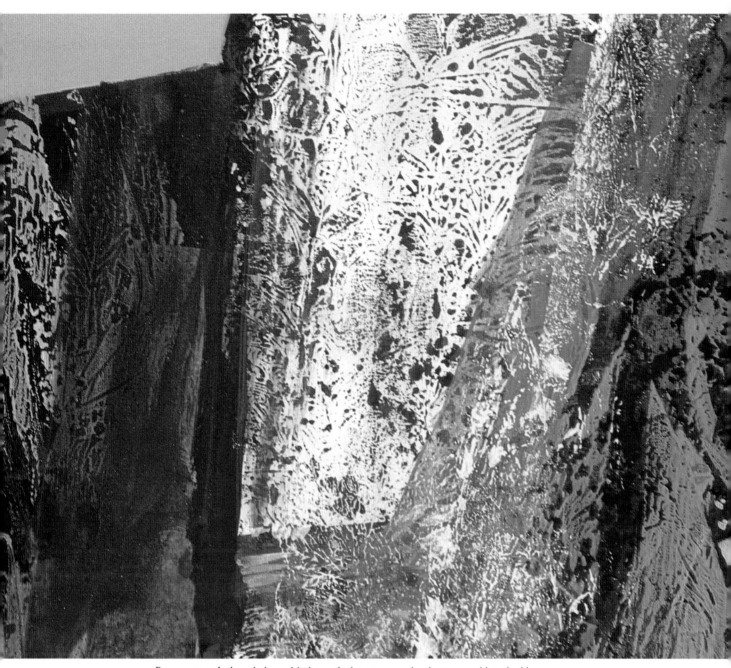

By repeating dark on light and light on dark patterns with ink, it is possible to build multidimensional layers of texture.

ADDING ACRYLICS TO INK

An acrylic medium is mixed with the ink undertexture to increase its density.

For a different textural effect, aluminum foil is used here in the same way as plastic wrap.

The addition of an acrylic interference color to the ink undertexture gives a luminescent quality to the color and lessens the intensity of the black.

ADDING TRANSPARENT WATERCOLOR TO INK

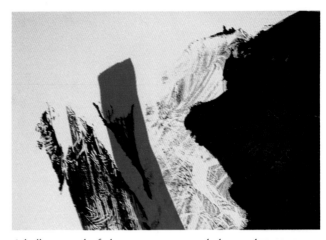

A brilliant streak of alizarin crimson is applied over ink textures.

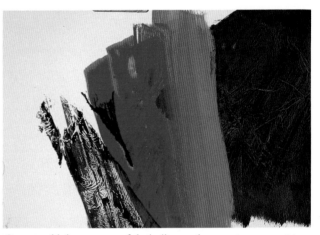

Gesso is added to an area of the brilliant color, creating a transition from the transparent to the opaque inked areas.

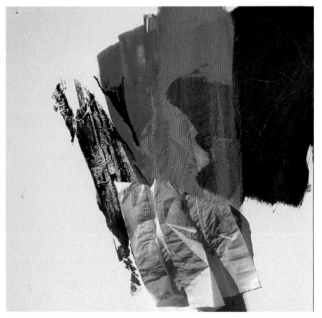

While the color is still wet, it is blotted with a paper towel, which allows the ink undertexture to show through in spots and tints it with a subtle layer of crimson.

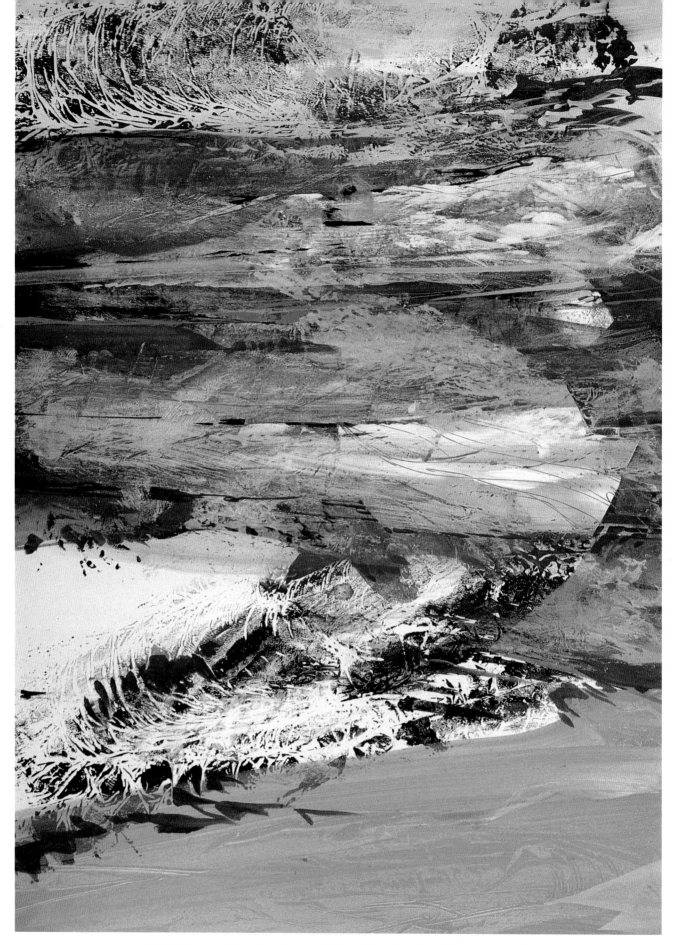

RIVERBED, watercolor and acrylic on 4-ply bristol board, 30″ × 22″ (76.2 × 55.8 cm).

This painting was built on an ink-textured base.

Undertexturing with Fabric

In the same manner that aluminum foil or plastic wrap were used, fabric scraps can also be used for stamping or printing color. The texture of the print will be determined by the weave of the cloth, varying from fine-toothed textures to looser and more random textures. By cutting and tearing the fabric and unravelling the edges, you can create an embossed look to the surface.

By using fabric scraps to lift and print color, you can impart a tapestrylike quality to your painting surface.

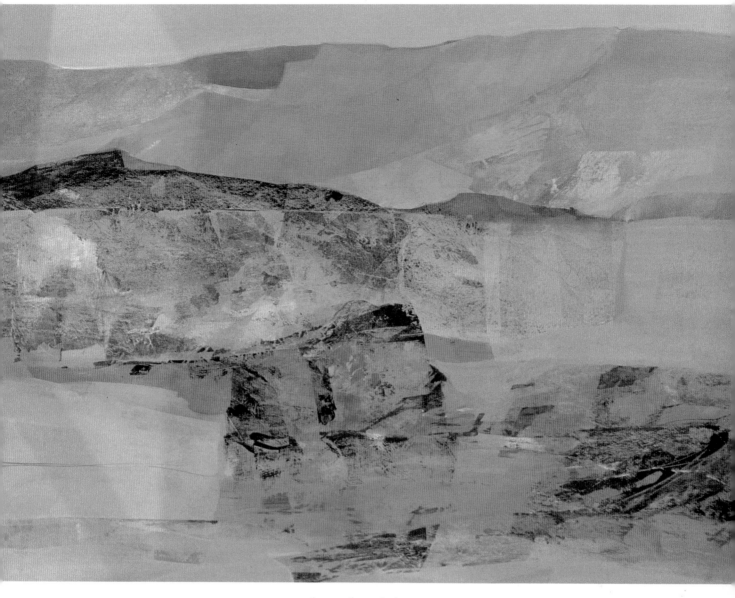

COLORS OF NEW MEXICO, watercolor, acrylic, and ink
on handmade paper, 36″ × 48″ (91.4 × 121.9 cm).

*To suggest the play of light and shadow frequently seen on rock walls and low desert
growth in the Southwest, fabric was used to print the textural pattern found in the
central area of this painting.*

Undertexturing with Colored Pencil

On occasion I like to use an underbody of built-up colored pencil texture in an area where I will want a brilliant color accent. The pencil scumbled texture is applied before painting or on top of the first washes after they are dry. By scribbling with a handful of pencils simultaneously, a color vibration can be effected. Thick-bodied paint is applied over this texture, masking it completely. While the paint is still wet, it can be scraped or blotted to allow areas of the undercolor to come through. The effect is quite different from colored pencil used as an overtexture.

By scumbling several different colored pencils across the paper at one time, you can establish a solid base of bright texture.

A thick opaque is painted over the colored pencil texture.

While the opaque color is still wet, the color is blotted and lifted away so that the pencil texture shows through.

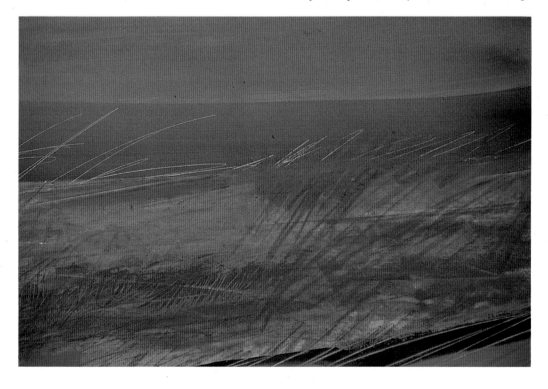

In this landscapelike detail, thin layers of opaque color were washed in over the pencil textures. Certain areas of the opaque paint were then wiped away to expose the undertexture.

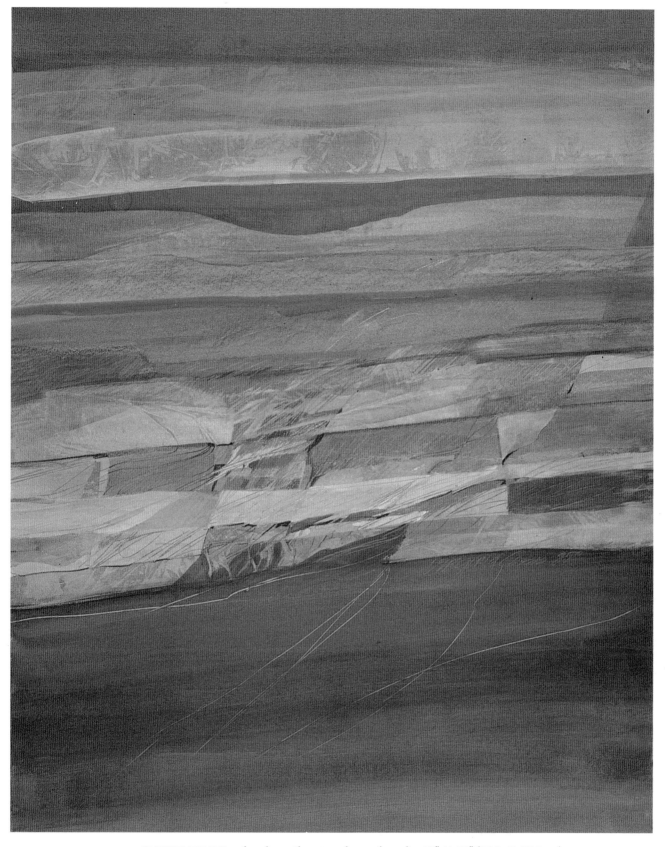

CANYON MORNING, colored pencil, watercolor, and acrylic, 30″ × 22″ (76.2 × 55.8 cm).

Brilliant undertones of colored pencil were scumbled over the central area of this painting before any of the paint was applied. The monochromatic opaque color forms were built on top of the texture and lifted off in areas where emphasis on the colored pencil undertexture was desired.

Collage Techniques

Because collage is not thought of as a medium with an accepted set of standardized methods and techniques, a great deal of creative work is being done today in this field. Each artist who works with collage will give you different guidelines, and all are worth consideration.

When I make a collage painting, I prefer to work on a soft, handmade paper that can be easily manipulated. Often I will make my own paper, typically a paper with some embossing on its surface. I find that this gives me a head start in creating a relief surface.

When making collage paintings, a built-up surface gives me a headstart.

My collage materials include fabric scraps, paper scraps (usually a handmade paper or a rice paper), threads, string, foil papers, and scraps of painted or printed papers that I have prepared for just this purpose.

Sometimes I make my own collage papers. For example, I will use good quality paper, such as a rice paper, to clean my small etching press or silkscreens. Thus, I have not only cleaned my presses, I have created interesting inked patterns on good quality paper. Once I've printed these patterns on the paper, I tear the paper into small pieces and save them for collage work.

I generally use an acrylic matte medium as a binder, unless I want a glossy surface. Acrylic matte won't alter the paper in any way or leave a shine where I don't want it. When I need to blend edges, acrylic can be painted directly into the color areas. When a silky finish is desired, I use Roplex, an acrylic plastic binder, which gives a soft sheen but not a high gloss.

WINDOWS 4, watercolor and acrylic collage, 32″ × 40″ (81.2 × 101.6 cm).

This painting is one of a series of window paintings in which I deliberately created an altered sense of perspective by enlarging the see-through forms and reducing the closed forms. The surface was built up using rice paper; the top layer incorporates two embossings I had prepared using my small etching press.

COLLAGE MATERIALS

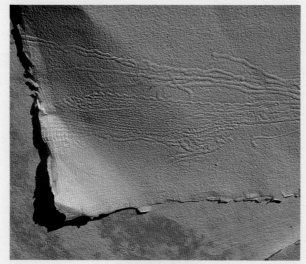

HANDMADE PAPERS

FABRIC SCRAPS

SILKSCREEN PAPERS

PAPER SCRAPS

ETCHED PAPERS

DEVELOPING THE COLLAGE SURFACE

Pieces are selected that work well together.

The surface is built up in layers.

Color areas are developed.

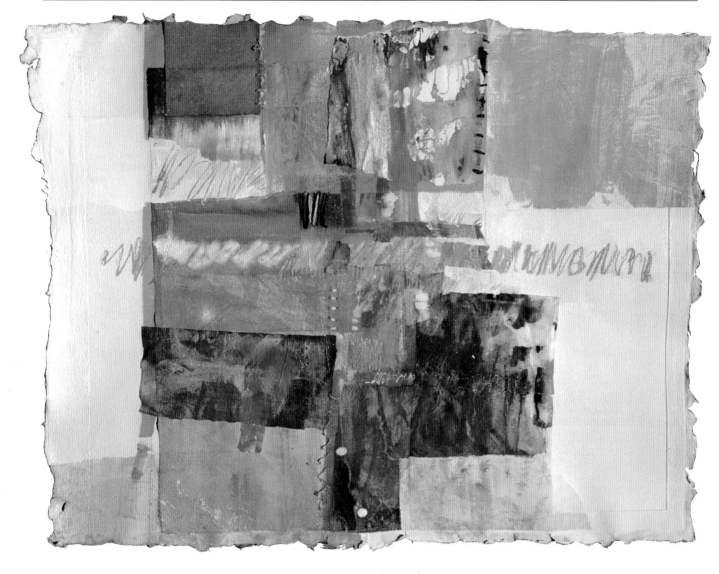

WINDOWS 12, acrylic and collage on handmade paper, 22″ × 30″ (55.8 × 76.2 cm).

The various pieces of this collage were "stitched" together with paint and with thread.

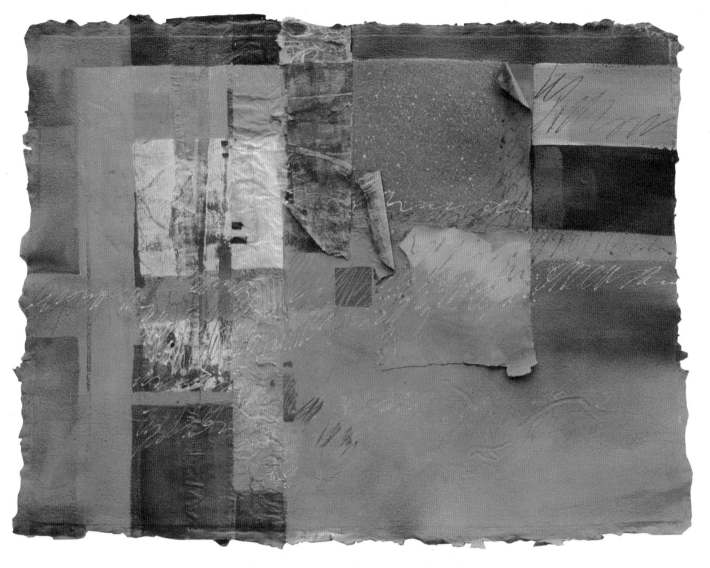

WINDOWS 16, acrylic and collage on handmade paper, 22″ × 30″ (55.8 × 76.2 cm).

In collage, the paper itself is part of the art form. Here the surface was developed on a large sheet of handmade paper in which I had inlaid a smaller sheet, leaving one edge loose to create a shadow form.

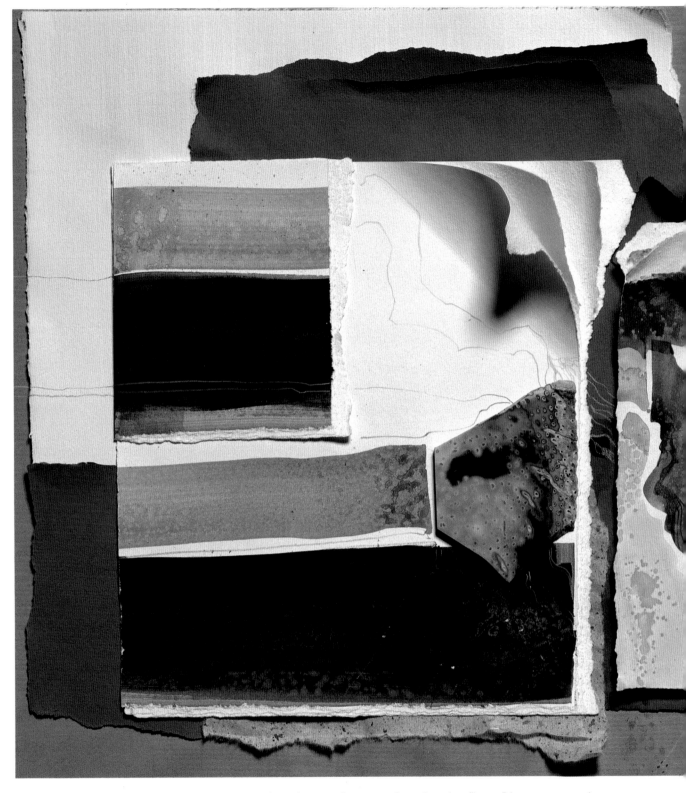

LAYERED CANYON, watercolor and stone collage on 4-ply rag board, 17″ × 22″ (43.1 × 55.8 cm).

This small construction/painting was done for my friend Murray who died in 1983.
We had worked together for a year on a series of layered canyon paintings. Shortly
before his death Murray wrote: "Our lives, like the paintings, are built in layers,
created one piece at a time . . . impossible to view as a whole until all the pieces are in
place . . . each in its perfect relationship."

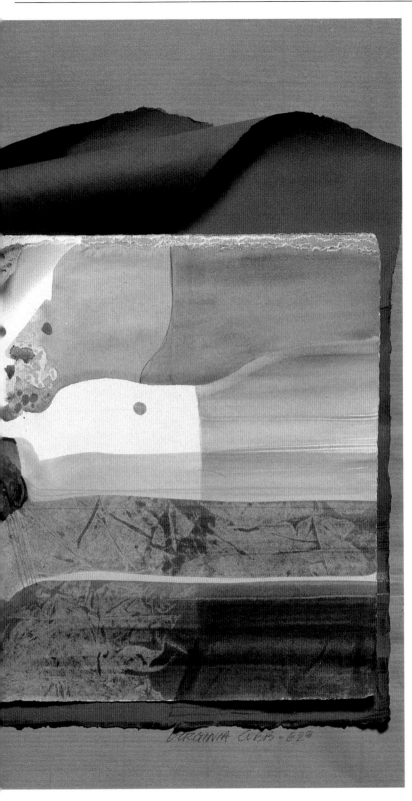

Constructing a Layered Surface

In 1982 I began a series of layered paper constructions that focused on the theme of layered canyon walls. Since that time I have found a number of other artists whose work is also built up in layers, all of us for one reason or another seeking a broken surface plane.

For the ground, I like to work with a four-ply or five-ply museum board. Museum board is very attractive and has a slightly textured surface. The board itself is one hundred percent rag paper and is composed of several layers that are adhered to each other.

There are many advantages to museum board. First, it comes in large sheets that measure 40″ x 60″, (101.6 x 152.4 cm), a substantial size which allows for any size or shape format up to those dimensions. (For paintings larger than 40″ x 60″, I extend the surface area of the ground by piecing together the boards onto a backing, such as Masonite or canvas. I have constructed museum board surfaces as large as seventy inches square.) Second, the multilayered structure of museum board makes it possible for me to separate the individual layers and create a multidimensional painting surface.

Building a Surface for Layered Paintings. To provide the support structure required for a layered painting, I lay one piece of museum board on top of another, often creating barriers between the boards with acid-free foam board to increase the surface dimension. These layered boards are then painted and purposely torn to create a three-dimensional painting.

Separating the Layers. Museum board layers can be separated and peeled back from each other with a razor blade that is turned slightly at an angle so that only the top layer is cut. This first layer is then carefully pulled away from the surface behind it. This underlayer takes paint very differently than the smooth outer paper does. The contrast between the two creates a nice contrast of textures.

To create a second curled-away section, I can make a diagonal cut in the other direction and lift another opposing edge. Color can be added to these areas, too. At this point, the curled-back forms start to take effect and dominate the design. The shadows cast by these curled shapes are as much a part of the design as are the shapes themselves.

CONSTRUCTING A LAYERED SURFACE ·

I begin by cutting into the multilayered board with a razor blade.

I carefully pull back layers where I want them.

Color is added to emphasize the divisions.

The color on the rolled-back surfaces will have a different texture than the flat surfaces.

To create multileveled layers, I simply repeat the process, carefully laying back each separate sheet of the four-ply board.

The shadows that are created with this technique are an important consideration in the overall design.

Rather than cut, these layers are torn apart by hand, giving them a more organic, freeform shape and texture.

Working with a four-ply board, I can usually successfully curl back three layers of paper. Occasionally, I will add another four-ply sheet behind the first sheet for an added dimension.

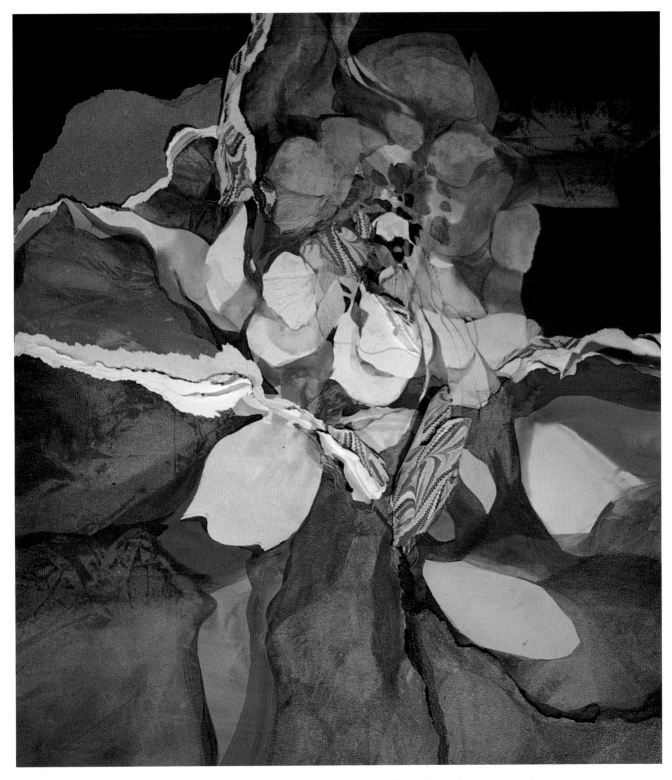

EARTH FORMS, watercolor and acrylic on 4-ply rag board, 38″ × 32″ (96.5 × 81.2 cm).

This painting is one of a series of flowerlike forms I made from a layered paper surface. The three-dimensional aspect of these paintings was very much a part of the overall design. The curled-back layers in this painting project as far off the surface plane as six or seven inches.

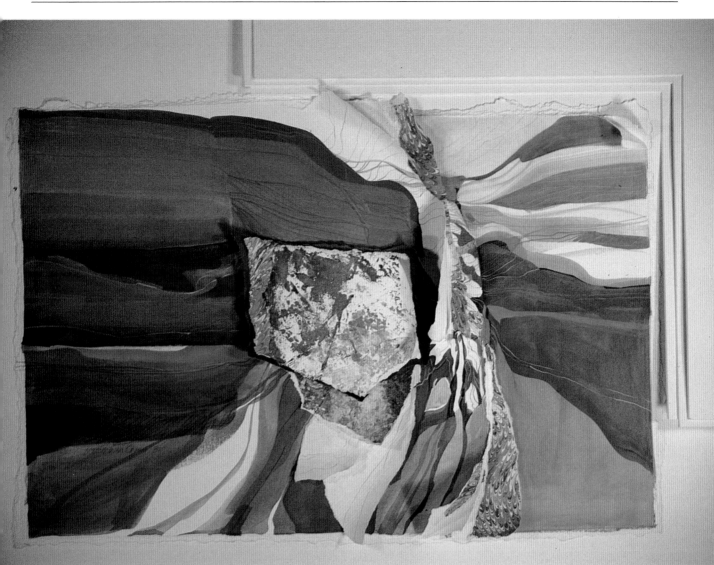

UNDERCURRENT, watercolor and embossed paper on layered board, 17″ × 22″ (43.1 × 55.8 cm).

The theme of this painting is the underlying currents of nature that run through and often determine the course of our lives. By peeling away the layers of paper, I was able to give a physical form to a symbolic force.

JUDGES, watercolor on paper, 22″ × 30″ (55.8 × 76.2 cm).

Part Four

QUESTIONS AND ANSWERS: IN THE SPIRIT OF DISCOVERY

*"The critic within the artist is prompted
by taste, highly personal, experienced, and exacting.
He will not tolerate within a painting any element
which strays very far from that taste."*

—BEN SHAHN

The Creative Process

In an effort to be a more creative teacher and to motivate students toward a more personal art form, I began teaching an experimental painting class in the 1960s. Through the years, I have found that teaching art has no absolutes. Each class became an experiment in itself because each group of students brought new energy into the process.

An experimental workshop is far more than a teaching/learning experience. It is an exchange of ideas among students and teachers, with each individual free to work from his or her own creative center. As the teacher, I start the momentum by throwing out a problem that can be solved in many different ways. Each student then becomes the catalyst for an original response, causing a ripple effect throughout the room. We all benefit from a cumulative creative energy.

Because the material from the workshops was the inspiration for this book, I have included in this section the questions—and in turn my answers—collected from years of teaching workshop classes. These questions and my responses have helped me to clarify my own thoughts about art and the experimental process. By using the ideas that have been raised in class, I hope to make you, the reader, feel a participant in this process. The answers to these questions are really meant to provoke more questions—to push you into more creative thinking.

Why Is Experimentation Still So Important in Your Work?

The implication to this question is that there is a point at which growth is no longer necessary. But an artist never reaches a point of finish; we are always in a state of growth, reaching for new solutions to problems and new methods of expression. I believe that is part of what draws us to art, the close-up, open-ended nature of creation.

For me the excitement in any project is the development of the idea. Once it is clear how a painting will turn out, finishing it is pretty routine. If I push myself by trying new techniques for expression, painting continues to be a moving and changing art form. I set in motion changes that bring new excitement to my work. Nothing would cause me to lose interest faster than knowing ahead of time what the procedure was going to be for a particular painting or what the precise result would be.

Why Did You Switch from Watercolor to Water Media?

I still work with watercolor much of the time. It is a very challenging medium—a truly experimental medium. It allows the freedom to change direction as you paint, to redesign, to create, to tamper, to play with the final result.

In the twenty years since I began to work in watercolor professionally, I have watched it change and grow. Once mistakenly considered a sketcher's medium, watercolor is now recognized as an important medium in its own right. Watercolor must continue to grow in order to hold this position in the art world.

Art forms change with time and the introduction of acrylic paints challenged both oil painters and watercolorists to invent new methods of painting—to keep up with new trends. At the time I was learning about watercolor techniques, I was fortunate to live in the southwestern part of the United States. The influence of both coasts came in via the watercolor workshops, but the emphasis in the Southwest was on experimental development of the medium, triggered by the dramatic visual elements of the environment itself. Painters who had mastered the traditional handling of transparent watercolor began pushing it with textural effects derived from additives, such as other water-soluble substances. The term water media became a descriptive label for work produced in that area.

Is It Okay to Combine Mixed Media with Transparent Watercolor?

This is, of course, an often asked question. To decide what is "okay" in any painting, ask yourself a question: What are your reasons for the painting?

If it is important for you to work in transparent watercolor using traditional methods, then try ways of creating textural effects by alternative layers of transparent color. Or, if you are interested in creating certain effects no matter what other media you may need, then it is best to experiment with any material available to achieve the desired result.

There are a few exhibits that are closed to mixed water-media entries. If you plan to exhibit with such a group, you will need an all-transparent painting for an entry. But it would be a shame to limit your expressive form because of such competitions. The idea would be to do both kinds of paintings to allow yourself unlimited avenues. I am concerned by the attitude I see among water-

colorists that the medium should be restricted. To my mind, watercolor is vital and alive. You won't threaten its existence with experimental techniques, you will only increase its potential.

If I Try Experimental Work, Will I Still Be Able to Sell My Paintings?

It is essential to understand your goals and to set goals that are realistic for your purposes. If painting is a way of earning your livelihood, you must consider your market and tune into your audience enough to produce a reasonable number of paintings successful to that goal. Nevertheless, it is necessary to polish your skill and search out new methods that will translate into your work in positive ways.

Allow yourself time to paint just for yourself once in a while, exploring expressive techniques. Budget your time if necessary. I know artists who set a goal of a certain number of paintings completed and then allow one day for invention—sort of like taking a day off for golf.

Reward yourself with time to paint for fun, for relaxation, for experimentation. The increased facility with your tools will pay you back with renewed creative energy.

We work hard as painters but because we love our work we sometimes feel it is not really work, so it is particularly indulgent to paint just for the joy of painting. Yet for the most of us that was the original reason for painting. By bringing back the newness occasionally you keep your work fresh. This freshness, this spark of vitality, translates into everything you do, and your work will have new life and new energy.

Do You Begin a Painting with a Subject in Mind?

The person who had asked this question explained that she was a "realist" who wanted (liked) to work with literal subject matter. My response was to ask her a question in return: "Is your real more real than mine?"

My paintings come from a very "real" source although my interpretation is not always literal. I start with a source, always, mostly with a nature form or landscape format in mind. It gives me a point of reference, somewhere to begin, a reason for the painting. With the subject in my mind's eye, I can begin flowing color on paper and establishing some of the textural buildup that describes the tactile quality of my subject. Often I allow a painting to change midway into something entirely different from my original intent. It doesn't matter anyway, because once I have started and am into the painting, my obligation shifts from the object/subject to the painting itself. By watching what is happening on paper and allowing the design of the page to be my focus, I can create a more personal statement about my subject and interpret it in a more intuitive way.

"In earlier times artists liked to show what was actually visible . . . nowadays we are concerned with reality, rather than the merely visible. . . ."
—PAUL KLEE

Once in a while I like to paint a realistic study of my subject. Usually these paintings are the early ones, painted when I am starting a series. Once I have acquired a working knowledge of my subject I am able to free myself to be more creative and less pictorial.

I have a young friend of fourteen, a very talented young man, who in the early days of our acquaintance would say to me of a painting, "What is it supposed to be?" And I would answer, "Shannon, it is supposed to be a painting. A painting isn't necessarily of something or about something, it is something." He would say, "Oh," thoughtfully. Our conversations became a game of sorts that always started with "What is it supposed to be?" but soon he began saying "Well, to me it looks like . . ." and his sense of seeing expanded with each game until he began finding subjects in nonliteral forms. This is the way we stretch our minds, challenge our view, increase our ability to see—learn to design more creatively.

Where Do You Find the Forms for Your Abstract Paintings?

In the most surprising places. I have a ring, given to me by my mother, which I call my energy ring. On it is imprinted the form of a dove. Often, when I begin a painting and have no particular source from which to work, I will use the image of the dove from my ring. It never fails to trigger some response.

While flying to a workshop recently, I was watching the sun set outside the window of my plane. Below I saw a small lake, apple shaped, separated by a projecting piece of land that cut the lake into two equal parts. The land, surrounded by a background of water, strongly suggested a long-stemmed flower with a single leaflike shape to one side. As we flew over, the light moved across the water like liquid silver, creating a strong re-

*The image of the dove
never fails to inspire me.*

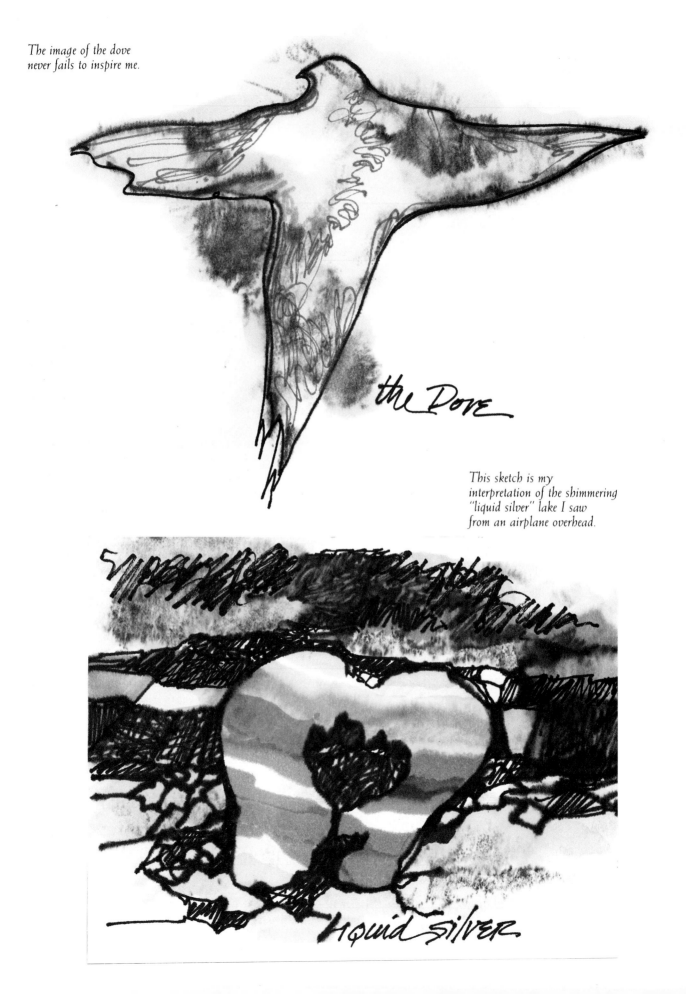

the Dove

*This sketch is my
interpretation of the shimmering
"liquid silver" lake I saw
from an airplane overhead.*

liquid silver

flection against the dark and textured land-forms. I quickly sketched in the shapes inside the book I had been reading and noted "liquid silver." From this image I have painted several paintings. I used to carry a sketchbook with me almost everywhere. The drawings that went into these books, collected over the years, gave me a vocabulary of symbols from which I can paint at will. In my present work I find gestural sketches more meaningful.

Every artist has a method of gathering material that is important to his or her own work. One artist I know paints from sketches she calls verbal sketches, in which she has captured the essence of a place. Another artist paints from her poems that are symbolic in nature. I know others who paint from very precise and detailed color sketches. Try all of these methods, find one that is particularly effective for you—and then allow that direction to change with time.

A camera is another valuable tool for collecting source notes. I have discovered that once I have seen an image through the viewfinder and snapped the shutter, that image is fixed in my mind's eye forever.

Is Abstract Painting as Easy as It Looks?

Although on the surface abstract painting may seem relatively easy, abstraction is no place for the unskilled painter who is not well versed in design. Too many abstract paintings seem unresolved and immature. This is true because it is fairly easy to learn how to apply color liberally in pleasing patterns. However, unless you understand the principles that tie together the pieces into a cohesive whole, your painting will be unconvincing and undisciplined. Once in a while the result will be something you're pleased with, but not often. You can't entice a viewer's attention with tricks; you must appeal to his or her intelligence.

If you are making a move from representational painting into abstraction, it's helpful to experiment with familiar subject forms, distorting them, magnifying them, and analyzing them in depth. These studies become good tools for abstracting design. Learning to abstract forms, like anything else, takes patience.

Is It Okay to Paint from Photographs?

Of course it is, but keep in mind that there are built-in traps you'll want to avoid if literal interpretation is your goal. The camera's eye creates distortions that must be compensated for when you translate the image to a painted page, or it will read as uninformed.

If, however, you are painting a photorealist image, the camera's distortion becomes an important element of your painted image. Distortion is part of the drama of such paintings. What you are painting is the camera's trapped view of a "real" image.

Now let me ask you a question. *What is a real image?*

Is "real" the camera's eye view we accept as real? Technology has trained us well. We actually believe that a small mechanical device sees more accurately than the human eye.

The camera's eye records only a captured fraction of our actual field of vision. You can prove this to yourself by making a camera-sized frame with your hands. Then, keeping your eyes focused on this restricted view in front of you, move your hands slowly to your sides until they have reached the parameters of your vision field. Describe to yourself what you are able to see now, as opposed to what you were able to see through the view with your hands held out in front of you. If our field of vision includes such a large expanse, why are we so quick to identify as "real" the camera's more limited viewpont.

Try the same exercise moving your hands up and down until they again reach the limits of sight. Which segment of our view is "real"?

Some areas within our field of vision are less clearly focused; some are seen with more of a fish eye perspective than a two-point perspective; some are in motion. Are these areas "unreal"?

The camera is only one more convenient tool for the painter. It can help you record and define and remember, but you must be willing to risk selecting what your reality of vision is. You must stretch your imagination farther than the camera's view to find what you see from your own unique place in this world.

The camera can be used in all kinds of ways to gather source material. For my work it is effective in collecting color and texture notes and for recording forms.

How Will I Know When a Painting Is Finished?

One of the most appealing characteristics of watercolor is that there are any number of points at which a piece might be called finished and still be an effective painting. In its early and most illusive stage watercolor has a fresh, spontaneous quality that cannot be duplicated in any other medium. Often a painting can be left in this most immediate stage because everything has worked well

together. This kind of painting requires taking advantage of the voluntary effects of the medium and manipulating the paint in such a way that a strong design is developed rather quickly. To go back into a watercolor at this point almost always requires reworking most of the surface to some degree. If you develop any part of it, the whole painting must be brought up to the same level of finish as the reworked area. I suppose that is why we are so often told it is necessary to get it right the first time and that a watercolor cannot be corrected.

There is no right way in watercolor and going back in to refine an area is not necessarily correcting a mistake but simply another way of handling the medium. Sometimes I build layers of color on layers of color after a piece feels fairly sound because I like more depth of surface color than a quick rendering will allow.

So how will you know when a painting is finished? A painting is finished when you are finished with it.

The Artist and the Critic

Almost anyone who enters juried exhibitions has heard the story of a painting, which, rejected from one show, won a top award in another equally prestigious exhibit. In fact, it happens often. The critic, the person who judges your painting, is giving an informed opinion, not an indictment, and of course, it is not unusual for two critics to have differing opinions.

A case in point is the painting *Judges* (see page 128). *Judges*, painted in 1972, was my response to the whole process of judging art: A catalog from one of the national competitions had arrived in the morning mail. It was the fifth year in a row that this exhibition had rejected my work. In the catalog was a photograph of the three judges, sitting in a row, each with his suitcoat off, tie loosened, left leg crossing the right, and in unison they were turning thumbs down on a painting. They looked very much like a chorus line to me, and I began thinking about how difficult it is to have your work judged. With this in mind, I began painting, first roughing in the chorus line dancing into the page from the far right. As I painted I began to see the humor in the situation. Collage elements were added using drawings from one of my classes. Our model had been one of those long-haired young men so much under judgement during that time.

Everything changes given time. I have since met each of the three judges, have won prizes in several exhibitions, and am often on the other side of the judging process. So I am now acutely aware that judging art is a subjective process, just as producing art is. As a critic, I can never really know the artist's purpose, or how the painting came to be. My decision must be determined by my response to the work. *Judges* hangs on the wall of my studio where it serves as a reminder of the artist's investment in the process of art.

Art is invention, not an exact science. There is no single authority who has all the answers because the answers change with each interpretation. We all seek some form of affirmation for our efforts, and it is valuable to have the opinion of someone more experienced concerning our work. But it is also important to keep in mind that a critic has no background for understanding totally the context of a particular piece of art. In the long run you must rely on your own judgement as to the success of your painting.

What Makes a Painting Successful?

This provocative question was asked of me on the opening day of a workshop. The morning had begun with a lecture on creative process in which I had stressed the value of inventive experimentation. I said that by experimenting with design problems you strengthen your sense of good design, which in turn will make your painting more successful.

To me, every painting, every work of art must reach a certain level of quality to be successful artistically, and it is a combined level of design, technique, and content. Technique and content are personal to the artist, developed through the years as you grow in understanding of your medium and motives. Design is the more scientific element of the process. There are guidelines for designing that will help you reach that artistic level with more consistency. The rules will not assure you success, however, and at times can act as a hindrance. To force a creative work to conform to rigid standards will destroy its creative quality.

We live in a product-oriented society that puts little value on personal expression unless it offers some kind of monetary return, such as an award or a sale. Only when we can point to the reward of the experience do we allow ourselves to say, "Ah, yes, that was a successful painting."

Should I Ignore the Rules?

In general, I consider the rules that have been established for painting merely guidelines for us to use in designing. A painting is far more than a design; it is an expressive art form. To reduce it to a formula is to remove the personal element from it.

Guidelines for painting were established for the purpose of freeing us to be more creative, for taking some of the guesswork out of the painting. They were never meant to be rigid boundaries beyond which painting should not venture.

Standardized procedures help us repeat what has already been done; they help us achieve an acceptable norm. To reach beyond the norm we must rely on our own ingenuity. I do not know of any single person who became an artist with the goal of being average.

Rules follow innovation; they do not precede it. The rules were made after some clever artists tried something new. Like any tool, a prescribed rule can be useful for strengthening your work. But if you have a good understanding of the principles of design, it is possible to break any rule successfully. Once in a while it is possible to break all the rules inadvertently and still have a good—even an outstanding—painting. But if your painting is only the result of accident, you won't be able to rely on this method, and your success will only happen occasionally. To paint consistently well, it is necessary to have a working knowledge of the basic guidelines.

One of the best ways I know to reach an understanding of a specific rule is to deliberately break it. That way you can work your way out of the problem you have created, and in the process come to understand the reason for a certain rule. My *Nesting* series was the result of my struggle with breaking the accepted idea that the subject should not be placed at the center of a composition.

What Makes an Award-Winning Painting?

Often an expressive painting that wins an award is the one that has broken the rules and engages the viewer's interest for that very reason. When I jury a show I look for that something extra that tells me the artist was fully aware and alert to the creative process of the painting. In short, I look for the authentic presence of the artist.

There are three criteria for judging a work of art: technique, design, and content. Although it's impossible to completely separate the three, it's possible to assign a higher priority to one over the others. Each juror will approach the task with a different opinion of which one of these elements is the most important.

Technique refers to the effective handling of your materials. A well-painted surface has a strong appeal to the technician in me. But often a less professionally handled painting will evoke a deeper response. How does one explain that?

Design is a very important ingredient in any painting. The standards governing good design are often precise; and they can guarantee a mistake-proof formula that can command attention in an exhibit. If you combine strong design with professional handling of the medium, your painting has the best chance of acceptance in the most competitive of shows. But there will still be that piece that defies both rules and technical proficiency and still win awards. Why?

There is a quality some paintings have that I call authenticity. This quality is a little less glib, a little less perfect—but honest. It is this personal element, or what I call content, that sets one painting apart from all the others, speaks of the artist, the unique inner eye, or "I" of the painting. As Henry Miller said, "To paint is to love again. It's only when we look with eyes of love that we see as the painter sees."

It is that quality of self that comes across in a work that sets it apart from the others. Content is not subject or idea; it is the artist's perception of subject or idea. Content is that quality that involves the viewer in the art process.

What Do You Mean by the Element of Surprise?

When you paint, do not underestimate your viewer. I have a very wise friend who says a work of art has three parts: the artist, the art, and the viewer. According to this philosophy the work is not complete until it has been viewed. If you close the viewer out by overstating, by leaving no surprises, you have in effect chosen not to involve him or her in the painting process.

The word surprise is one I often use in critique. I became aware of my use of this word when sitting on a critique panel with a prominent artist from the East. His comments went something like this: "It is pleasant enough," or, "It is well painted," or, "It is quite strong" and then he would pause and say, "but where are the jewels?"

On another occasion, I was working on a

jury panel with an artist who commented on one painting: "It leaves me with no questions. I find myself saying, surprise me."

These artists are saying the same thing. A successful work must catch your attention in some way. It must make the viewer want to stay with your painting a moment or two longer.

Surprise can be accomplished with color, by placing it in an unexpected place. A sense of surprise can be created with a line or form that breaks the surface of the paper or the established rhythmic patterns of the overall design.

Surprise can happen when an element is somehow out of context, or in an area that refuses to obey the laws of perspective. It can also be something that makes me smile or frown, but, above all, makes me look back one more time.

What's Wrong with My Painting?

A woman in one of my classes once asked me if I would mind looking at a painting of hers that had recently been rejected from a show. She wanted to know what was wrong with her painting. I asked her if the painting was different now than it had been before the show. Obviously she had been pleased with it originally or she would not have framed it and submitted it to an exhibit. Too often we quickly condemn a work because it did not receive the response we desired. Yet there's not something "wrong" with a painting that doesn't get into a show. You have simply chosen the wrong purpose for it. Learn to distinguish between work that has a more general appeal and work that is more self-involved. The painting in question was an expression of intense feeling but perhaps the involvement was too subjective to allow viewer response.

In general, uncontrolled, personalized emotion in a painting won't hold the viewer's interest. This is true because, outside the artist's immediate circle, few people can relate to such a piece. An artist must negotiate between the point that is too readable and that which is incomprehensible. A painting should be nearer a comprehensive emotional center.

If you have a strong emotional involvement with your subject, don't paint it just once and try to make one painting be everything. There is much you can say about that subject; it deserves to be explored more fully.

If something is worth painting, it is worth painting again and again. And each time you paint this subject, you will understand it and your responses to it better—the whys of painting it. It is the *why* of painting that is important, not the *how*. Take the time to explore your feelings about this subject, the different symbols you would choose to represent it, the ways your interpretation can change with each successive attempt.

When you have painted your subject or theme several times, put the group of them together and try to evaluate them objectively. Choose the ones that are strongest in design and that speak most clearly of your feelings. Then submit those paintings for exhibition, as they represent the strongest and clearest statement on that subject.

But don't throw out the others and call them failures. Each one will have some quality that makes it part of the whole statement. We never arrive at complete understanding without a growth process. Each painting is a step toward an understanding of your subject.

Can You Give Me Some Guidelines for Entering Competitions?

Although I have never had much use for don'ts, the following is a list of common misconceptions and/or mistakes that I see artists make in submitting their work to a juried exhibition.

Trying to paint for the juror. It is a mistake to try to second guess a juror by painting in a style you think will please, but which is not your usual painting style. Hopefully, the person selected to jury has a broad enough background to appreciate paintings that differ from his or her own. You have a much better chance of acceptance if you paint with conviction in your own style.

Painting the subject that won last year's award. In any show there are a disproportionate number of entries that are take-offs on an award winner from one of the recent catalogs. Jurors tend to look at those entries skeptically. When your painting is an award winner you can expect variations on it to show up in exhibits for years to come. Most jurors have had that experience.

Emulating another artist's work. Art is a funny business; there are no binding rules, which is what allows us our creative freedom, but we must set our own ethical guidelines. Most jurors will not look at a painting they suspect is a copy.

Taking rejection personally. A juror does not have time to deliberately snub you. Jurying a show is a long and involved process; and while it may seem to be done effortlessly and sometimes carelessly, it is not. The juror is interested in putting together a whole show of the pieces she or he considers the best representation of the work submitted.

My own method is first to select those works that will be the key paintings in the show—the standouts. Everything else is brought into that group to see if it can hold its own. There is usually no point at which I draw a line and determine that everything on one side of the line is good and everything on the other bad. What typically happens is that I reach a point where if I add one more piece, I would have to add ten more equally deserving ones, and the show can only handle so many.

Letting success, or lack of it, change your perspective on your work. Success can be a trap—a heady trip that stops your progress while you repeat a formula that works over and over. Sooner or later, you will become bored with your predictable outcome, and boredom shows up quickly on paper, revealing itself to the viewer. In order to keep your work fresh, you need to push your work in new directions.

On the other hand, if you let a few disappointments convince you that your paintings don't have merit—or worse, that you are not qualified to paint, you are making a terrible mistake. Keep in mind that a show is similar to a game, a contest, and approach it with that attitude.

And most important, I would suggest that you never accept one judge's opinion as final. If you truly believe a work to be an exhibition painting, always give it a second chance. The most informed critic about your own paintings is *you*. You alone know where the painting came from, what purpose you had in painting it, and whether it meets the criteria you had set for it. One way to grow as a painter is to learn to evaluate your own work objectively.

How Can I Learn to Critique My Own Work?

During his or her painting career, an artist is confronted by many critics. The most severe of these is the critical self. This is the voice that must be tempered if you are to accomplish what you hope; yet this is the final voice in any judgment of the validity of your work. Only you know if you have realized your goal in a painting.

The critical self can be trained. As an artist you have an innate sense of taste that governs your decisions. Learn to tap into that resource and be guided by your own built-in sensibilities rather than by too many outside voices which will say to you, "but it can't be done this way!"

During critiquing sessions, I have found that a student, given the chance, will automatically go to the problem area and say, "This feels wrong." This is your inner critic at work rejecting the contradictory elements that create discord in the painting.

The first lesson in teaching yourself to critique is to allow yourself to praise your own effort. It is so easy to look at the work of another artist and see its lovely qualities, its effective passages. However, when our inner critic turns its eye on our own work, it can be ruthless and negative. The first and most important step in critiquing any painting is to find what is working well. Seek out the color passages, textural areas, value relationships that work the best, and then see to it that the weaker areas are effective in relation to those areas that work best.

Applaud the good passages and take real pleasure in the parts of the painting that are well executed. Critique is an evaluation; it is crucial to understand that in evaluating your work you are weighing both the positive and the negative. Too many people approach critique as if it were a demolition session, not an evaluation session. The objective is to find your strengths and use them as guides against which you measure the rest. Sometimes the strong areas can carry the weaker areas. When that is true I would suggest you consider leaving some areas a little unresolved. It is possible in polishing a painting to perfection that you might reduce its expressive nature and dilute the statement you wish to make. Be forgiving of passages that are not "perfect" but that work well in the overall context of the painting.

After you have identified the strongest areas in your painting, it is fairly simple to pinpoint those passages that detract from and weaken the overall effect. In time, every artist develops a method of critiquing. For me it is helpful to leave a finished painting on an easel for several weeks just for the purpose of editing it. Sometimes I walk into the studio with my morning coffee and recognize the precise area that is asking for some minor change that will strengthen the whole painting.

Above all, don't be in a great rush to call a

piece finished. In time you will gain the objectivity you'll need to allow you to make revisions and to refine areas that might greatly improve the finished work.

Of course, after the concentrated time and effort you give a painting, it's not always easy to be objective about it. Objectivity requires removing yourself from personal involvement and viewing the painting as if you were a stranger coming to it for the first time.

A mirror in your work area is helpful for this purpose. Seeing a painting reversed will surprise your eye by shifting the weights. You can usually sense any imbalance in the composition rather quickly this way. By turning a painting upside down, you are again shifting the emphasis of the piece and giving yourself a more abstract view of your design. Either of these simple methods will help you to switch into your more analytical frame of mind.

When critiquing your own work, it's important to see each painting as individual and to keep clearly in mind what it is you want from this particular work. You can't treat all paintings the same way. Each requires something special from you.

As you evaluate your painting, ask yourself these questions:

What effect do I want from this painting? All paintings cannot be addressed in the same way. If you were designing a painting that needed a "path of entry" that lead the eye into and across the surface, the problems you would encounter would be very specific. If, however, your painting was designed to be an all-over-pattern that had no specific focal point, you would be wasting your time worrying over so-called paths. So first, identify the effect you are seeking, then see to it everything in the painting increases that effect.

What are the surface relationships? An important part of painting is the development of surface quality which changes where one shape touches the next. There are many ways of creating these surface relationships, and you must decide which is most effective for the individual painting. A lot of the subtlety or drama of a painting takes place where the surface changes from warm to cool, light to dark, textured to smooth. Make clear decisions about what effect you want from these transition areas, and see to it they create that effect.

Are the transition areas well integrated? Often it is the treatment of edges that separates a painterly surface from one which seems awkward and unresolved. Examine the edges of forms and see to it there is a graceful quality to these transitional areas.

Have I established the mood that best expresses this subject? Mood is a very important part of designing. Through line, color, form, and texture, you create a mood that evokes response from the viewer.

Compare your work only to your own best work. In evaluating your paintings the best gauge you have of growth and maturity of style is the work that preceded this effort. As you explore ideas and techniques your understanding of them increases and your confidence grows. To compare your work to the work of another artist is not fair to you or to the other artist. It's easy to take the work of another artist and reproduce the effects without understanding how the artist arrived at these solutions. You might create a credible facsimile, but it will lack authenticity.

We all paint what I call milestone paintings once in a while. These paintings seem to just happen and are far beyond our current ability. In effect, they are a look ahead to what we hope to achieve. These magic moments of painting are exhilarating and they mark our progress. Sometimes it seems a long struggle to reach the next plateau of painting, but that is a worthwhile goal—to reach a level of accomplishment consistent with your own best work.

It's also a good idea to occasionally reassess your work to see if you are following the path you have chosen. It is easy to get sidetracked by a little flash of success, and stall in motion, repeating the familiar and tried. After a while you lose your enthusiasm for the original idea, and your new work will lack the spark the earlier pieces had. With time our ideas change, our understanding increases, and our goals and purposes change. Allow yourself to move on, even if it means feeling your way through unfamiliar territory and painting with less assuredness. Search for new and vigorous expressive means—look forward.

Trust your own judgment in critiquing your work. Make the painting work the way you choose. Take charge, make the decision, and move on to the next painting. Remember, never discard an idea because it does not conform to the rules. Bend the rules to conform to your idea. Believe in it enough to work with it over and over, to polish it until it becomes decisive. Then people will make rules about that—and we will all do it your way.

Problem Solving

The old belief that you can't rework a water-color is nonsense. In fact, it's a necessity. When paper became so costly, artists began looking for ways to save that "lost" page. It is often economic situations that trigger new trends in art. I believe that the cost of materials in this inflated period in history has affected the ways in which many of us use our materials.

What Can I Do about Muddy Color?

I quarrel with the term muddy color. I do so because I happen to be one of those painters who love so-called muddy color, only I prefer to call it gutsy color. If my entire painting were filled with vibrant, pretty color, I would have nothing left to key it against for contrast. It is only when I place a contrasting flat color against a brilliant one that I get the full effect of brilliance.

However, if your intention is to maintain a purity of tone in a particular area of your painting, I suggest you try not to stir around too much in the dark areas. Paint your darks in directly—with as few strokes as you can manage. Then if you want to add a color, float it onto the dark color and allow the two to blend. They will retain more of their pure color if they are not smudged.

If the Foreground Is Weak, How Can I Add Interest Without Changing the Emphasis of My Painting?

To bring interest into an area of a painting that doesn't hold its own in the design, I often use what I call overtexturing. Overtexturing can be accomplished in several ways. For example, you can add a bold color to an area to provide that extra excitement some paintings need. Or, you can liven up an area that has gone dead with opaque lights. Another interesting technique is to use a good strong black over a color area. Black over color can crisp up an area and create impact where there is no punch.

If the Background Comes Forward, How Can I Push It Back?

I have found that a very effective method for dropping an area back into the picture plane is to wash over it with a thin veil of gesso or one of the iridescent acrylics. This is also an excellent way to calm down a busy area.

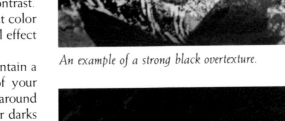

An example of a strong black overtexture.

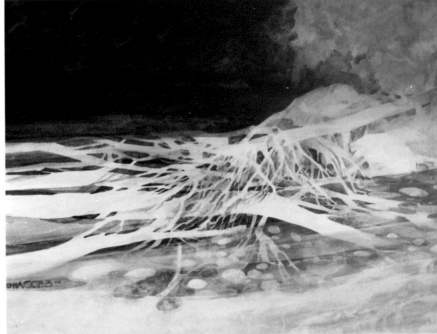

In this example a thin wash of tinted gesso was used to tie together the foreground shapes and submerge the forms beneath the water flow.

Conclusion

Throw a pebble into a pond and watch the perfect circles form and spread effortlessly. Think of your art as that circle—a circle of creative energy spiraling out, taking in new influences, reaching out for new experience— but always coming back to center—to you.

Your art comes from you. I've heard people say there is nothing new in art, but no artist has viewed the world from exactly your position and created from the center that is you. We each have the ability to take whatever it is that makes our lives unique and weave that together with the influences around us into an art form that is original and fresh.

If we are open to all the possibilities and willing to risk untraveled paths, the potential is unlimited. It takes patience; our lives are built one piece at a time. It takes courage; we must believe in ourselves enough to seek what is truly individual. It takes a certain amount of playful abandon. As Henry Miller said in *To Paint is to Love Again:* "The remarkable thing to observe in children's work is that the child gives the impression of having done it with his whole being. They surrender themselves completely to what is at hand."

We all need to make time for playful inventiveness, to surrender ourselves to what is at hand, and to bring from that experience renewed creative energy.

Acknowledgments

Many people have given creative energy to the unfolding of this book, each in some way an essential part of the whole.

Bob Hogue worked with me from the beginning and without his generous involvement I would never have started. He organized my material from class notes and lecture tapes. He photographed the outdoor work sessions, and he acted as my co-writer on sections of the text.

Pat Ballard spent long hours feeding text into a computer, tossed ideas back and forth with me, and contributed valuable input. Together with Doug Ballard, she proofread the manuscript. The two of them were my loving support system throughout.

Ed Harley generously gave technical advice as well as moral support at a time when both were needed.

Al Brouillette gave me courage to begin.

Bonnie Silverstein, a friend I look forward to meeting, gave cheerful encouragement to continue.

Candace Raney with skill and sensitivity edited the text, adding the polish it needed for completion.

Jerry Friedman arrived in time to help me give a name to this adventurous offspring.

Bob Bluntzer's superb slides were the original inspiration for the slide show "What's real to an artist?" which in turn inspired the book.

Other slides vital to the text were provided by: Polly Hammett, Norma Jones, Katherine Hauth, Jerry Olson, and Pat Ballard.

To all of you my thanks.

Index

Edited by Candace Raney
Designed by Bob Fillie
Graphic production by Ellen Greene